Creative Pen & Ink Techniques

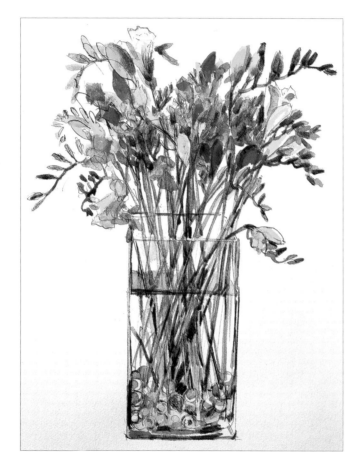

Creative Pen & Ink Techniques

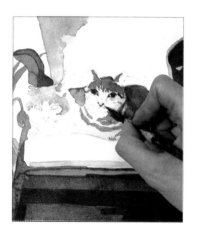
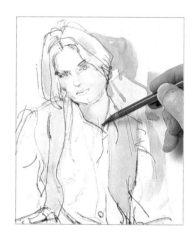

NORTH LIGHT BOOKS
Cincinnati, Ohio

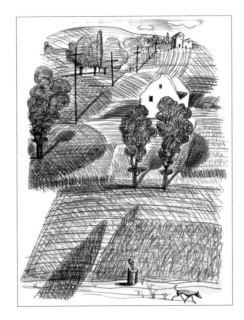

Based on *The Art of Drawing and Painting,* published in the UK
by Eaglemoss Publications Ltd
Copyright © Eaglemoss Publications Ltd 2001
All rights reserved.

First published in the USA in 2001
by North Light Books
an imprint of F&W Publications Inc.,
1507 Dana Avenue,
Cincinnati, Ohio 45207

ISBN 1-58180-247-1

Printed in the Slovak Republic by Polygraf Print spol.s.r.o.

10 9 8 7 6 5 4 3 2 1

CONTENTS

INTRODUCTION

For centuries ink has been one of the most favoured drawing materials for discerning artists. Used well it has several unique qualities, including a strength and crispness of line which, with practice, can be used with both bold expression and fine subtlety. Such attributes have made ink the popular choice for illustrators whose work is reproduced on the printed page, particularly when the drawing needs to be precise and unambiguous.

The immediacy of ink, however, means every hesitant gesture or indecisive tremor of the hand or arm is telegraphed through the pen or brush and into the mark being made. This often has the effect of giving the drawing a distinct quality which, like handwriting, is unique to the person who made it. It is perhaps this very attribute, together with the difficulties encountered when trying to make corrections, that cause some people to regard ink as being difficult and unforgiving. Not that it is as easy or as straightforward to use as, say, graphite. But most of the commonly encountered problems can be easily solved with a little forward planning – by using an underdrawing made in easily erased graphite as a guide, for example, or by working with an ink that is water soluble. Indeed, mistakes can often be satisfyingly incorporated into the piece, rather than clumsily disguised.

At the time when the civilizations of ancient China and Egypt flourished, the brush was traditional tool used to apply ink and its adaptable shape gave the artist great scope for creating expressive and calligraphic marks.

The pen in the shape of a feather quill originated during the early Christian period and although the quill has now been replaced by the steel nib, a pen is what many people tend to see as the main tool for making ink drawings.

The 20th century, however, provided the artist with a wealth of tools that has extended the material's potential considerably. Fountain pens and 'art', or sketching, pens make working on location easy and clean. Fine liners and ball points enable detailed line drawings and cross-hatching to be prepared relatively quickly, while the vast range of coloured felt pens and fibre tips available make excellent sketches and drawings. Furthermore, coloured inks allow work to be created that incorporates many of the techniques more commonly associated with watercolour. None of the techniques or tools used in preparing ink drawings need be used in isolation: all can be intermixed and often used to great effect together.

For the beginner or more experienced artist, the amateur or professional, few things are as satisfying and fulfilling as the execution of a good drawing, and executing a good ink drawing arguably gives the best sense of satisfaction and achievement of all.

Ian Sidaway,
London

Pens, inks and papers

There is a wide and ever-growing choice of pens, inks and papers on the market today. Try to keep an open mind about your choice as this will extend your creative potential.

Thanks to recent manufacturing developments, there are hundreds of pens and inks available, and you can work with them in literally countless ways – from simple monochromatic drawings in traditional black Indian (India) ink to detailed paintings in brilliant colours. But whatever your interests, it's important to choose the proper materials for the result you have in mind.

Traditional drawing pens

Pens made from natural materials – quills, reeds and bamboo – were for many centuries the only types available. They are still popular today because they're pleasurable to use. If you look after them, they can last a long time. They all make their own characteristic marks, and they're cheap and easy to handle.

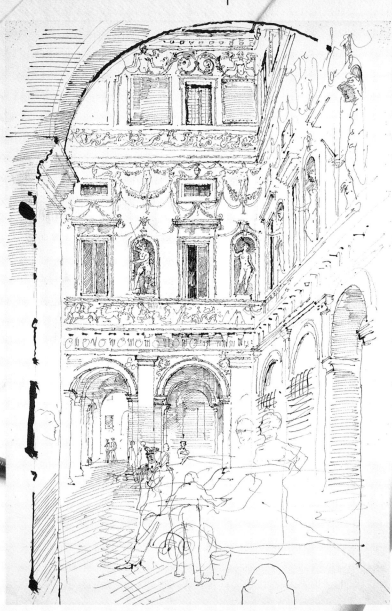

▼ Pen and ink can be used to create both boldly expressive and delicate line. Here the artist described the building's detail with a fine-nibbed dip pen.
'View through an Archway'
by John Ward, 190½x 12½in
(48 x 32cm)

◄ Dip pen holders can be fitted with a wide variety of nibs, all of which can be used for drawing, whether specifically designed for the purpose (such as the pointed drawing nibs), or for calligraphy (such as the square-ended nib, or the script nib, which has a bulb-like end), or for mapping. When selecting pen, ink and paper for a drawing, you will need to consider their compatibility (see page 15).

Quill pens, made from the flight feathers of large birds such as swans, turkeys or geese, are light, flexible and responsive. Quills can be bought ready-hardened and cut to a point for drawing or calligraphy. Alternatively, of course, you can find feathers, or buy them from farmers or butchers. If you make your own quill (see page 22) you should harden the feather first, either by cutting the tip off and plunging it into hot sand, or by just hanging it up and leaving it to cure for at least a year. If you use a freshly picked quill, it will be very soft and will need to be re-cut frequently to maintain a usable point.

Reed and bamboo pens can be used to make a range of bold and vigorous gestural lines and marks. They too can be bought ready-made or you can make your own (see page 22). Reeds are rather more difficult to obtain than bamboo (which can be found fresh, growing in gardens, or dried, in the form of garden canes, from garden centres). Reeds have a little more flexibility than bamboo and so are capable of slightly more sensitive marks, while bamboo can provide a greater range of different widths of pen. Both reed and bamboo pens will soak up the ink thirstily, so they need to be kept well supplied, and they respond well to papers with a textured surface.

▲ Pens with fine nibs are superb for drawing thin lines and making many precise details – notice, for example, the balconies and windows here. After the forms were mapped in, thin washes were added for the tonal contrasts.

A page from a sketchbook by Anne Wright

◀ This portrait of a German Shepherd Dog was drawn with a technical pen. The artist used a technique called stippling – applying hundreds of tiny dots and flecks of ink. Stippling is time-consuming, but it allows you scope to consider the tones carefully.

'Mickey' by Sue Smith, ink on board, 8 x 12in (21 x 30cm)

▲▼A turkey quill (above) and reed pen (below) are responsive natural pens, and a pleasure to use. They allow you to draw smooth, fluid lines.

Technical pens (with an assortment of nib sizes) are used for engineering and architectural drawings. They produce a line of uniform thickness, which can be useful for hatching and stippling.

Dip pens and their nibs

The shape of the pen holder can have an effect on the way you hold the pen, so make sure that it feels comfortable.

Drawing nibs are long, pointed and flexible. The split in the point of the nib allows it to splay open under pressure, so increasing the thickness of the line. Be extravagant and experiment with different brands – there is a surprising amount of variation in nib behaviour.

Mapping pens are useful when a very fine nib is needed. Some are sold with their own holder.

Calligraphy pens The pointed, flexible copper-plate nibs are basically a pointed drawing nib. The square-ended nibs (which, for writing, are held at a constant angle) offer the artist an interesting ribbon-like line. For an additional supply of ink, they can have reservoirs attached to the front or back of the nib. Script pens have a bulb-like end to the nib, and can offer an interesting range of marks.

Refillable pens

Pens that carry their own supply of ink (in reservoirs or cartridges) are more convenient than dip pens when a portable pen is needed (as a sketching tool, for instance). Fountain pens are popular with many artists. Technical pens offer a precise and consistent line (with nibs, or 'points', in a series of measurements).

▲ Here many lines describe the model's form. Dilute washes of watercolour paint provide the dark tones.
'Naomi' by John Raynes, pen and wash, 21 x 16½in (54 x 42cm)

▼ **Expressive textures and tones are achieved by hatching and cross-hatching in selective areas.**
'Farmhouse Scene' by Gordon Bennett

▼ **Bamboo and reed pens (below) are superb for making thick, bold lines, but aren't particularly suited to drawing very precise details. A fountain pen (above) is portable and easy to use – a good choice for sketching outdoors.**

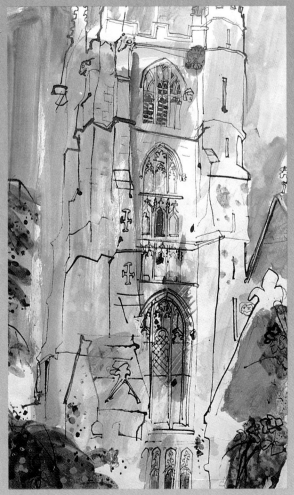

▲ The addition of other media – pastel was used here – can extend the range of pen and ink. *'Customs House, Kings Lynn' by John Tookey, pastel, watercolour and ink, 11 x 15in (28 x 38cm)*

▼ Burnt sienna ink was used for the pen line and tonal washes of this monochromatic image. *'Still life with Primulas' by Dennis Gilbert, 16 x 12in (41 x 30cm)*

▲ Areas of colour and tone were washed in with a brush and allowed to dry, then pen and ink was used to draw the detail of the architectural features. Note the variety of lines in the church – they give spontaneity and freshness to the whole composition.
'Norton St. Philip Church' by Stan Smith, gouache and ink, 15 x 11in (38 x 28cm)

▼ Round watercolour brushes (sable, synthetic or a mix of the two) can be used for both watercolour and ink washes. The brush can also be used as a drawing tool to add expressive marks to your pen and ink drawings.

◀ Watercolour gives colour and texture, while the pen and Indian ink line describes the detail of the bricks, cobblestones and the wooden doors. *'Times Past, Southwark' by Gillian Burrows, watercolour and pen and ink, 16 x 11in (41 x 28cm)*

▼ There are many ranges of coloured inks which can be used with pens or brushes. Chinese brushes (below) offer an interesting alternative to watercolour brushes. Always wash them very thoroughly after use with ink.

Ready-to-use pens

The variety of drawing pens that have been developed in recent years is overwhelming, offering a fantastic choice for the artist.

Each pen and each brand has its own specific characteristics – whether felt-tip, fibre-tip, hard plastic tip, metal tip, ballpoint, rollerball, with liquid ink, pigmented or dye-based, water-based or spirit-based, water-resistant after drying (or not), lightfast or fugitive. There are brush pens, marker pens, calligraphy pens, and technical pens. Probably the most useful additions to the pen-and-ink repertoire are the fine-line drawing pens that are available in a wide range of colours.

When selecting a pen for a particular purpose, read the labelling carefully, and try it out on a piece of paper in the shop. See how the ink line reacts to moisture, both before and after the ink has dried. And remember that the word permanent can be misleading. Some pens are very fugitive, others will last a long time, but it is unlikely that any are truly permanent if exposed to the light.

Inks

One of the most significant characteristics of a drawing ink is its water resistance once dry. A waterproof ink will not be affected by subsequent work with water or ink whereas a water-soluble ink can be softened. Inks have different characteristics: thin inks will flow quickly, some dry more slowly than others, some are specially

▼**Brilliant concentrated liquid watercolours are actually water-soluble inks, which aren't generally lightfast. They come in a wide range of colours with handy dropper cap bottles.**

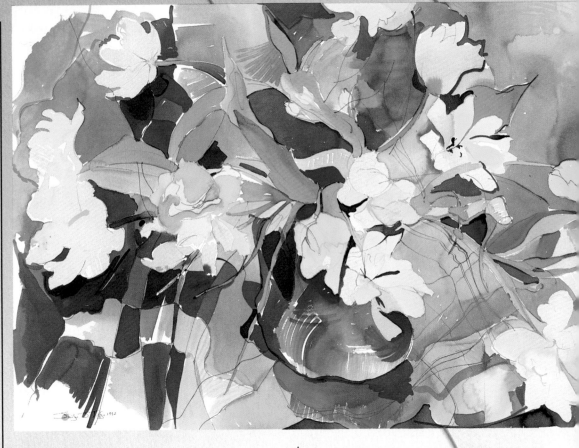

▲ **Liquid acrylic inks are available in both transparent and opaque colours. They are pigmented colours and therefore more lightfast than dye-based inks.**
'Highgate Jug, Hampstead Tulips' by Jennie Tuffs, liquid acrylic ink, 11 x 16in (28 x 41cm)

designed for fountain pens. Always clean ink from a nib when you stop working.

Waterproof Indian ink and Chinese ink both give a good dense black, and can be diluted (ideally with distilled water) to give graded tones of blacks and greys. Indian ink is also available as a non-waterproof ink. Chinese ink can be bought in a solid stick form which has to be rubbed on an inkstone with water, giving a high-quality ink, over which you have control of the darkness and viscosity.

Coloured drawing inks – the transparent, dye-based (and therefore fugitive) variety – were the most popular option until the introduction of pigment-based acrylic inks offered a more reliable, lightfast alternative. Start with a small range of basic colours (a yellow, red and blue) and mix them to create other colours.

Papers for pen and ink work

Of prime importance to a pen-and-ink drawing is the surface of the paper. A smooth paper will allow the pen to glide across it, while a rough one will give resistance. Smooth surfaces are provided by smooth drawing paper, lineboard or hot-pressed watercolour paper. Watercolour paper is also available with a not-pressed (or cold-pressed) surface, which has a little more tooth; and also with a rough surface, which is heavily textured.

Consider the weight of the paper if you are using washes – the water will cockle lighterweight papers as it dries. Common weights are: 90lb (190gsm), 140lb (300gsm) and 300lb (640gsm).

Most papers are sufficiently sized (a process that alters the absorbency of the paper) to prevent the ink from spreading, but it is as well to be aware of this factor.

CHAPTER ONE
Getting to know your medium

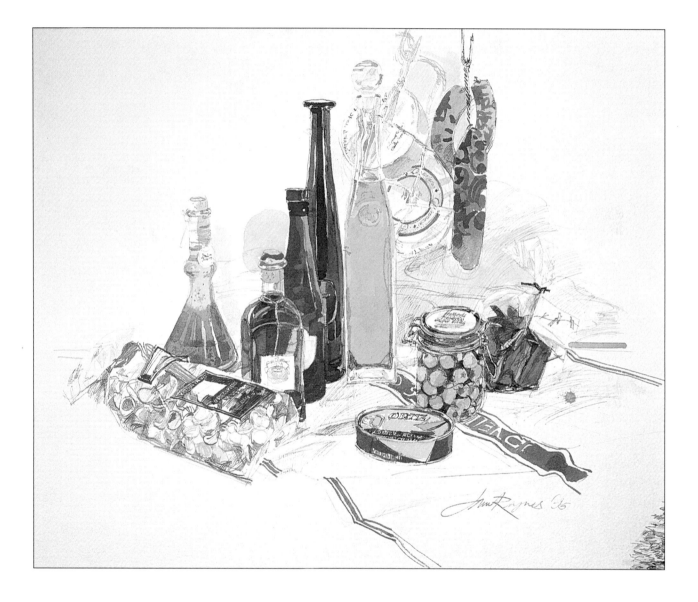

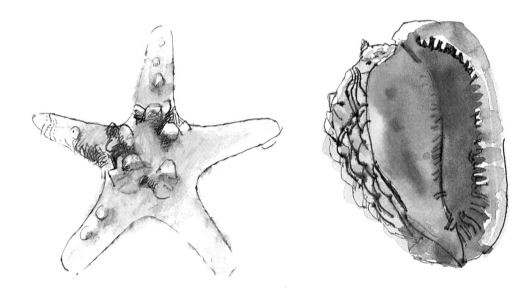

Matching pen and paper

Drawing pens all have their own special qualities and are suited to particular paper surfaces. It is useful to experiment, matching different pens and papers, to learn how to get the most out of them.

The type of drawing pen you choose can greatly affect the way you work and your end results. Different supports also add to the variety of effects you can create with drawing pens. So experiment with the whole range of materials and explore the creative potential of pen and ink.

For the demonstration here, the artist worked with three types of drawing pens, choosing different supports each time to show how his technique varies from pen to pen. He chose a fine-line drawing pen for his first drawing, working on a smooth surface (equivalent to smooth drawing paper). This combination called for detailed hatching and cross-hatching and attention to detail. For his second drawing he worked with a fine-nibbed dip pen on NOT watercolour paper. The thickness of the lines can be varied, creating room for more expression and resulting in a free-flowing image with an emphasis on line.

For the final drawing, the artist combined a medium-nibbed dip pen with the bold, lyrical lines of a quill pen, using subtle ink washes to integrate tone with line. Rough watercolour paper complemented the striking textured marks created by the quill.

YOU WILL NEED

- Three 15 x 22in (38 x 56cm) supports: lineboard, NOT and rough watercolour papers
- A dip pen and fine and medium nibs
- A fine-line pen
- A quill pen
- An HB pencil
- A No.6 round brush
- Black ink and water

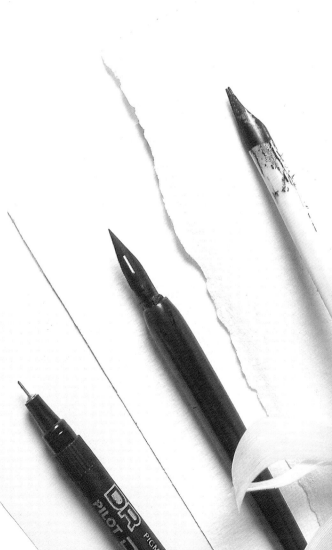

▲ This composite drawing makes a direct comparison between the different effects of the drawing pens and papers featured right.
With the fine-line drawing pen and lineboard combination (above left), the artist created a crisp, graphic image full of tonal complexity. In the middle section (fine-nibbed dip pen and NOT surface watercolour paper) the hatching is much looser and more open, and the emphasis is on the strong, calligraphic contour lines. Thirdly, ink washes (applied with a brush) supply the various tones on a rough paper (above right), with lines and deep tones added with a quill.

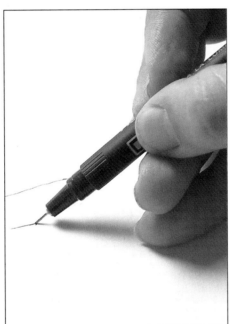

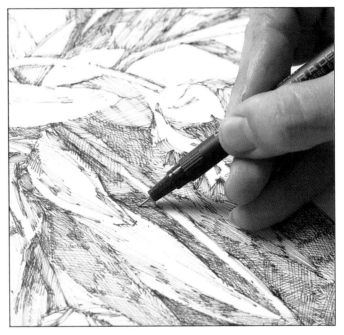

◀ The set-up The strong pattern and tonal contrast of the tulips provide a good subject for these pen-and-ink drawings. The artist chose a quiet blue vase and a pale background which allow the tulips to dominate. Pens offer the control and precision necessary to explain the complexity of the intertwining stems and leaves.

To emphasize the difference in the three approaches the artist used the same set-up for each drawing. Do the same yourself, perhaps choosing a pen you've never used before for one of the drawings. Be prepared to try new approaches, and allow the media to take you where they will.

Fine-line pen on smooth paper

▶ 1 For this first interpretation of the subject, the artist worked on a sheet of lineboard (smooth drawing paper or hot-pressed watercolour paper provide an equivalent surface). Begin by lightly drawing the subject with an HB pencil – this acts as a guide for your pen.

Now establish the major outlines. Simply choose a place to start and allow the image to grow from there.

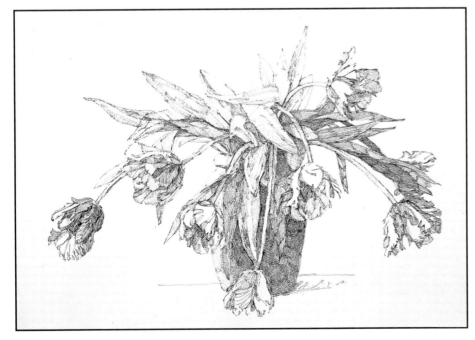

▲ 2 You can't build up solid blocks of colour with a fine nib, so tones have to be built up by hatching and cross-hatching. Assess the tones and their relationships to one another and start to bring them up to their correct values, varying the spaces between your lines for a wide range of tones. The smooth surface of the board (or paper) is necessary for the fine nature of this work.

◀ 3 Once you have established the image it's much easier to see where you need to darken tones. Work back into the deepest tones between the leaves until you have a good sense of depth.

Note how the artist has used the direction of the hatched lines to explain the planes of the subject. He varied their directions greatly – if they all pointed in the same direction the eye would follow them off the page.

Dip pen on NOT watercolour paper

► **1** For his second drawing, the artist worked with a fine-nibbed dip pen and ink on NOT watercolour paper. Once he had established the composition with the HB pencil, he began with the dip pen on the left, working systematically across towards the right to avoid smudging the ink with his drawing hand. As you re-state your pencil marks, make the most of the fluidity of the pen to create flowing contour lines. Hint at the more prominent shadows by applying greater pressure on the pen – this opens up the nib and allows more ink to flow.

◄ **2** This combination of media isn't particularly suited to fine hatching. Instead, the artist enjoyed the free-flowing quality of the nib, using the varying line to indicate how the light falls. Try holding the pen at the top end to encourage a loose approach.

Dip pens have a tendency to spatter, and the slightly textured surface of the paper will encourage this. Turn this characteristic to your advantage by using marks to suggest texture and pattern.

► **3** In the final picture you get a sense of the artist's enjoyment of the lines – in the crinkly petal edges and the curves of the leaves. These lines also bring out the finely grooved texture of the leaves.

With so few tones to play with, the artist has made a feature out of pattern in this drawing. For instance, note the bold interpretation of the patterns on the petals, and the decorative linear effect of the elegant leaves.

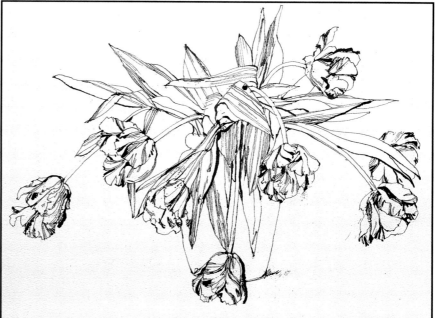

Quill pen on rough watercolour paper

▶ **1** For this final version, the artist began by working in a base tone over the skeleton of his pencil drawing, using the No.6 round brush and fairly dilute ink washes. Work across the page, allowing the ink to puddle where you want darker tones, and leaving the paper blank for the palest tones.

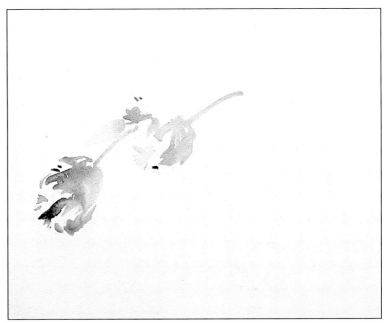

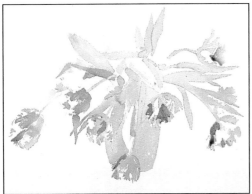

◀ **2** Once you've blocked in the composition, work in the mid-tones with a slightly stronger ink solution, working over the base wash in some areas for a warm, rich tone and to produce some subtle variations.

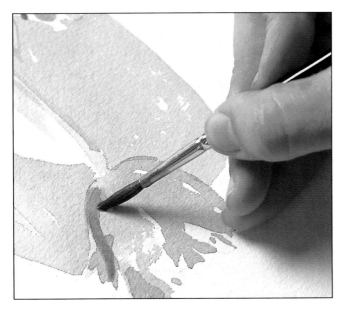

▲ **3** Don't overdo the mid-tones since you want to make an impact with the pen work, and too many brushed-in tones may detract from the quality of the pen lines.

▶ **4** Now start to emphasize contours with the pens. Our artist chose a combination of a medium-nibbed dip pen and a quill pen with a broad nib which he had cut himself (see page 22). Use both pens and undiluted ink to establish the form and texture of the petals, marrying your marks with the tonal suggestions you made in the previous steps.

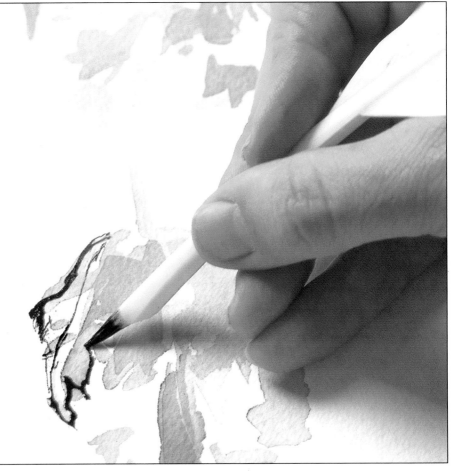

▶**5** Draw in the leaf outlines, switching from the quill pen to the medium-nib to make smoother, thinner lines. Work across the page in this way, reinforcing the positions of the flowers and leaves.

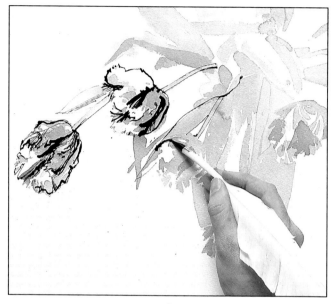

◀**6** Develop the darkest tones, such as the red marks on the petals, building up strong blocks of tone by placing broad quill-pen marks side by side. These strong shapes contrast well with the softer brushmarks.

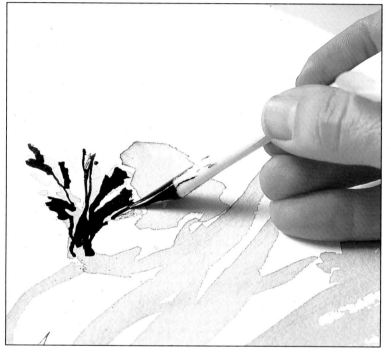

▶**7** Add the texture of the leaves and petal edges using both pens. Make the most of the variety offered by the pens, drawing parallel lines of varied spacing to describe the surfaces of the leaves, and using spatters and crinkly lines to convey the texture of the petals.

In the final drawing, the darkest tones and broadest pen marks belong to the flowers – the main focus of attention. With the variety of lines on the leaves, the artist has created a dynamic sense of their long, thin forms. The pale washes provide a unifying link, pulling the whole thing together.

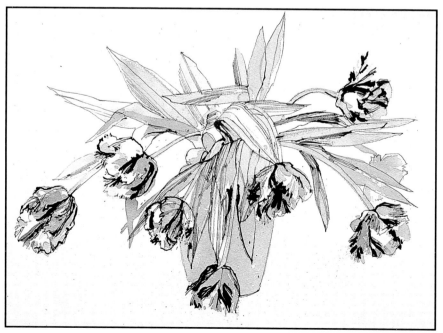

Comparing the effects

Once you've finished your three drawings, pin them up side by side on the wall to compare the effects of the different pens and papers. Which effects do you like best? Which do you feel was best suited to the subject? Which way of working did you enjoy most? Perhaps you can think of interesting ways in which to combine the different pens and washes.

▲ Fine-line pens allow you to build up some very detailed tonal effects, so assess the tones in your subject carefully. Note how the tight hatching on the vase helps it sit behind the leaves and flowers.

Although fine-line pens come into their own when used on smooth paper, they leave a lovely staggered line on rougher surfaces which can be exploited for texture-making.

▲ Examine the variety of line here – it ranges from fine whispers to crisp, bold statements – all from the same fine-nibbed dip pen. This pen encourages a very loose, free approach which many artists enjoy. There's a lot of room for spontaneity, and the joy you take in the free-flowing lines will add to the appeal of the drawing.

► The quill pen and medium-nibbed dip pen produce the boldest lines. They work well with ink washes because their thick marks aren't lost under the grey tones – a fine line might vanish.

Don't worry about spatters and splodges with quill pens – these characteristic features enhance the charm of the drawing.

Reed, bamboo and quill pens

Pens made from natural materials can be bought ready-made, but they are easy to make, offering the opportunity to create a custom-made nib size and shape to suit your drawing.

In this technological age, you'd be forgiven for dismissing pens made of reed, bamboo or quill as primitive, even inferior. But look at some of the drawings of the Old Masters – Rembrandt and Goya, for instance – and, bearing in mind these were among the few materials available to them, you may reconsider their value as drawing media.

These pens create lines with wonderful fluency and vigour. Compared with the more regular lines of a modern steel-nibbed pen, these natural materials offer a variable line which can flow from thin and delicate to bold and broad. This variability gives the pens an individual character that you can't always control. Blots, scrapes and impromptu changes of line thickness will bring excitement and an interesting textural quality to your drawing. And because you keep dipping the pens into ink, your marks will be slightly blurry or broken, adding more charm.

Quill pens can be quite scratchy, and therefore suit smooth drawing paper. Bamboo pens tend to glide over the surface, so choose a toothier paper such as watercolour paper. Dilute your ink to make it flow more freely. Try using these pens on toned paper, and in conjunction with other materials, such as chalk or pastels.

▼ Quills, reed and bamboo pens are inexpensive, easy and fun to make.

▼▶ These two drawings were both made with home-made pens – the sunflower on the left is drawn with a quill (with some finger smudging to provide tonal variations) and the flower on the right is drawn with a bamboo pen.

Cutting a pen

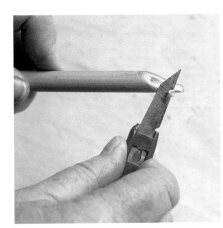

◄1 To cut a bamboo pen. Cut an 8in (20cm) length of bamboo. Starting at about ½in (1.5cm) from the end, make a 45° diagonal cut with the junior hacksaw. Cut off the very tip, again at a 45° angle. This tip is the part that will mark the paper, so for thin lines you need to take off a small amount, and for broader lines, cut a wider tip. Carve away the sides of the nib to produce the required shape, directing the blade away from your body for safety.

YOU WILL NEED

- ☐ A length of bamboo (available from your local garden centre)
- ☐ Junior hacksaw
- ☐ Craft knife; cutting board
- ☐ Bradawl
- ☐ A few quills (goose, swan or turkey feathers, available from art supply shops)

►2 Turn the pen over so the nib rests on the board. Use the craft knife to cut a split along the middle of the nib, making sure you cut right through the bamboo. This will aid the flow of the ink, which is held in the slit and slowly released as you use the pen.

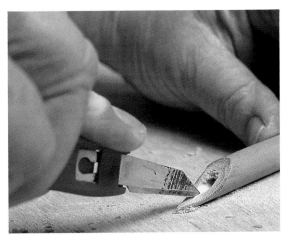

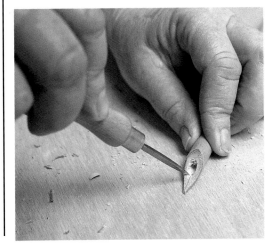

◄3 You now need to make a small reservoir so that your pen will hold a little extra ink. Bore a small hole at the base of the split with a bradawl.

Your bamboo pen is now ready for use. You may want to repeat this process at the other end of the bamboo, cutting a thicker nib this time. Remember, you can repeatedly re-sharpen your nibs with a craft knife to keep them fresh and clean.

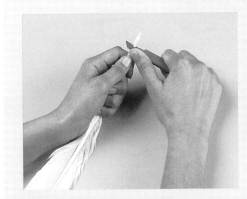

▲1 To cut a quill pen. Hold the quill so the feather curves upwards towards you, then insert the craft knife into the hollow stem at a 45° angle, about ½in (1.5cm) from the end. Stop when you have cut a third of the way into it.
Note: always make sure the craft knife is directed away from your body.

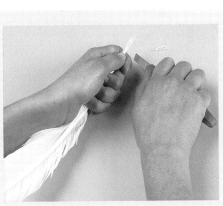

▲2 To shape the nib, level off the angle of your craft knife so you are cutting horizontally along the length of the hollow. Cut all the way to the end. Do this slowly to give as much control as possible. You can cut towards you which provides greater control, but it's a much more dangerous way of working.

▲3 To complete the shaping, turn the quill over and cut a slit into the middle of the tip as with the bamboo pen – you need to do this carefully since the quill is quite delicate and can easily bend at this stage. You now need to shape the nib. Cut away the sides of the nib leaving the very tip of the quill at the thickness you require.

Dip pen and ink

A script pen nib offers a versatile range of marks with the dip pen. Here it is used with non-waterproof ink, which gives the opportunity to adjust lines and tones after the ink has dried.

Pen and ink is a useful medium for sketches; a scene can be quickly rendered, with few materials, and with great impact. Choosing a non-waterproof ink gives the artist the option of adding tones to a work and blurring the hard edges produced by the nib. A scene can be sketched quickly and with a real sense of spontaneity, but this doesn't mean the work has to lack warmth and a sense of depth. Using sepia ink instead of black, for example, can lend a softer, old-fashioned quality to a picture.

There are no rules about the type of pen and nib you choose, but variety of line gives a livelier, more interesting result. This can be achieved with a script nib, for example, which has a 'bulb' at the tip that makes for a thick, bold line, or, if used in reverse, produces finer details and several interesting marks and lines.

Because ink drawings require a bold approach, it is helpful to plan your composition before you begin – either in your head or on the page in pencil. In this demonstration, the artist sought to give the work a three-dimensional appearance by keeping her finer nib strokes to the background and by working up thicker, bolder lines in the foreground.

▼ Non-waterproof ink gives you more versatility than water-resistant ink. Here, for example, the artist has washed over the grasses at the front with clean water to soften them, capturing their dry, feathery quality. She used diluted ink to wash in the bushes and trees along the river in a mid-tone.

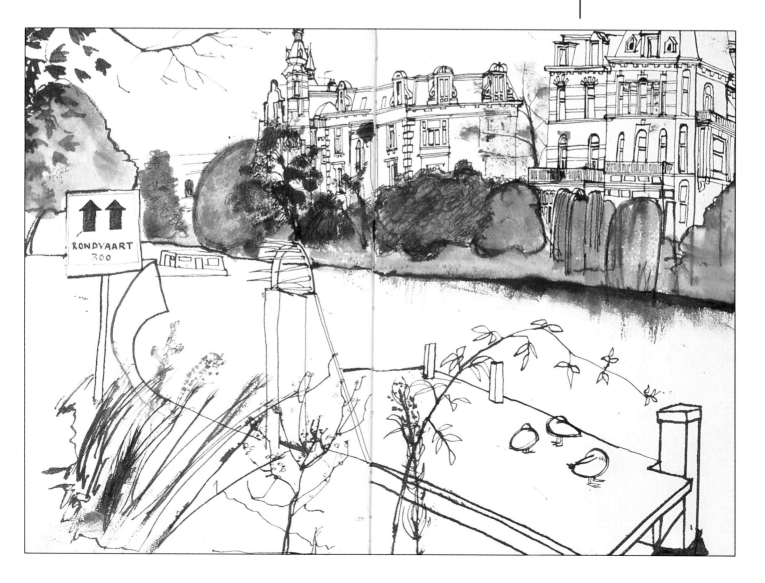

Old Amsterdam

YOU WILL NEED

- [] A sheet of 11 x 14in (28 x 35cm) watercolour paper
- [] A medium drawing nib, a ¾ script pen nib with built-in reservoir, and pen holder
- [] Two jars of water
- [] No.2 round brush and a large old brush
- [] HB pencil
- [] Paper tissues
- [] Eraser
- [] Higgins non-waterproof Sepia Calligraphy ink

The set-up The artist chose a street scene in Old Amsterdam from her sketchbook. She used a non-waterproof sepia ink, in case of accidental spillages, and also to add some subtle tones in dilute washes to the finished work. She used only two nibs – the most versatile being the script pen nib with the round, bulb-like tip.

◀**1** Start with a few pencil lines to assist with correct perspective. Beginning on the left, use the reverse side of the script pen nib to draw the fine vertical lines of the buildings. Pay attention to the base line where it meets the street and vary the plane accordingly. Use the right side of the nib to describe the thicker horizontals of the base line and window ledges.

▶**2** Once you are a quarter of the way across the page, move on to describe the chairs and bike in the foreground – these help to give a sense of scale. As you work, be conscious not only of the outlines but also of the spaces between the objects – this enables you to define the scale and proportion of the picture.

▼**3** An easy way to draw a three-dimensional grid, such as the bicycle basket, is to adopt a systematic approach. Use your drawing nib and wipe it frequently with a tissue to ensure a clean line free of blots. Draw the basic outline of the basket (**A**). Continue describing the vertical and horizontal grid on the left side and at the front. Then draw in the grid of the base and back (**B**). Finally, describe the lines on the right side and thicken the base lines of the basket (**C**).

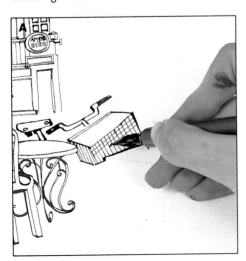

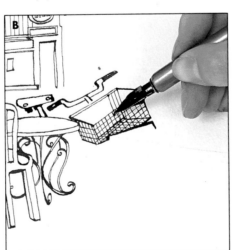

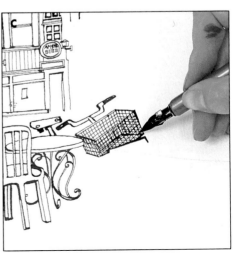

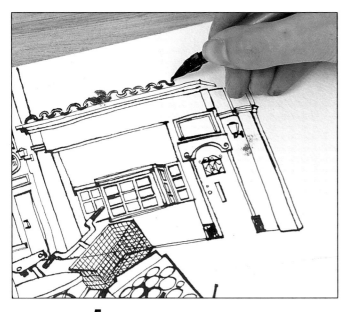

◀4 Move back to the buildings and, using both sides of the script pen for variety of line, draw the shop front, door and the curly edges of the tiles. Aim to portray the character of the buildings, using pattern rather than fine detail. Change to the drawing nib to emphasize the nearest lamp. Dab any blots with tissue.

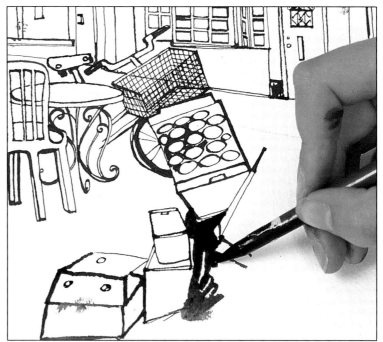

▶5 Use the end of your brush handle or a stick to achieve a free flow of ink to draw the contrasting rough lines of the cardboard boxes and the soft, voluminous contours of the rubbish bags. Aim for a high concentration of ink, spreading the colour with the tip of the brush handle.

◀6 To draw the edge of the curb, use both sides of the script pen nib and aim for a bold, gutsy line. Start with the edge of the pavement and, without resting your hand on the page, draw a free line with the right side of the nib. Holding the pen like this helps create a strong line and prevents smudging. Reverse the nib and adopt the same technique for the finer lines of the curb.

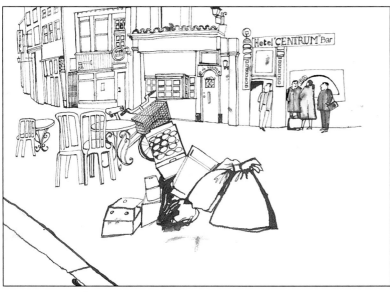

◀7 Use the right side of the script pen to detail the main architectural features of the Hotel Centrum. Apply a concentration of ink at the top of the doorway for depth – this will be washed through as a tone once it has dried. Draw the outlines of the people in the street, then use the No.2 brush and clear water to solidify the figures, picking up colour from the drawn lines. For darker tones add more ink.

Using a script pen

Script pens – with a round, upturned, bulb-like tip – are traditionally used for lettering, but they can be used to great effect for pen–and–ink drawing. They have a built-in reservoir which gives a constant flow of ink and reduces blotting and spattering.

Experiment by holding the nib at different angles to the paper, and also by rolling the pen handle between your fingers. A down stroke with the 'bulb' flat on the paper gives a thick line, while an up stroke (holding the pen upside down so you are using the reverse side of the nib) gives a much thinner line. Try a variety of nib sizes to see which one you like best.

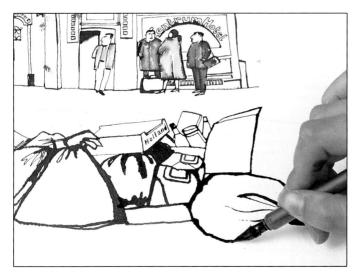

8 Emphasize the perspective of the picture by developing the lines on the containers in the foreground. Use the script pen nib and the handle of the old brush to achieve a variety of bold lines. As you draw, concentrate on the composition, taking care over scale and perspective.

9 Use the clean, wet No.2 brush to wash a pale sepia tone in the doorway, pulling the ink down from the top. Add a few shadows to the rubbish bags and boxes in the foreground by smudging the drawn line downwards with your finger. Use the script pen for the shop sign and to refine background details.

10 Add the building on the far left and apply a wash around its contours to emphasize the deep perspective at the top left of the composition. Draw the background line of the pavement with the drawing nib. Adding the building and bicycle on the far right also helps the perspective. Now erase the pencil guides.

The finished work demonstrates the freedom and spontaneity of pen-and-ink drawing. The artist has skilfully managed to convey depth in the work by highly selective use of sepia tone for the figures and buildings.

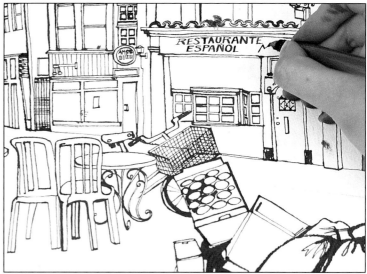

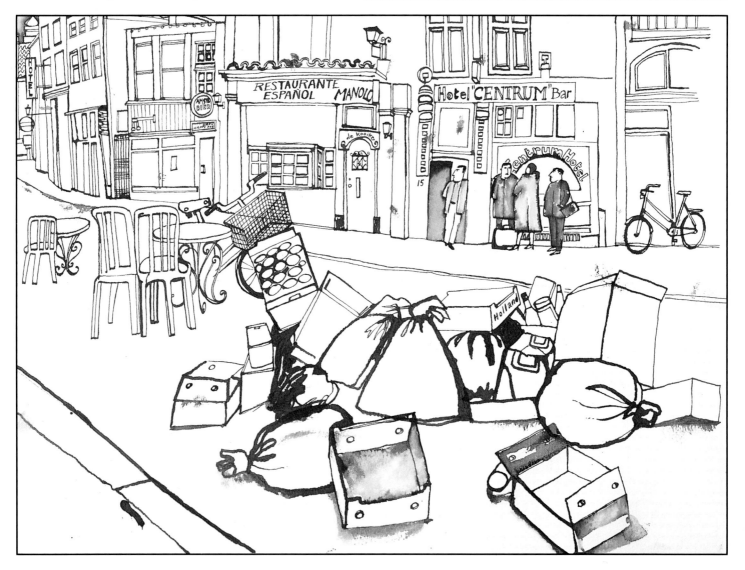

Watercolour accents

While pen-and-ink line drawing has a pure, austere beauty of its own, adding a touch of bright colour can produce some eye-catching results.

Watercolour makes a marvellous partner for pen and ink. The combination of pure black line with gentle transparent watercolour washes or with selected areas of strong, bright colour can make a drawing 'sing', and result in a picture of great charm. With this approach you get all the crispness of pen and ink and the bonus of fresh watercolour with its variations in colour, tone and texture.

An artist may lay down washes of colour first, then draw into them, using the pen line to bring out shape and form. Or you can apply colour washes over a pen-and-ink drawing – giving you the opportunity to be more selective about how much and where you want to apply colour. You may allow the colour to melt into a freshly drawn ink line that isn't quite dry, or let the ink dissolve into a loose colour wash. The degree of control is up to you – it depends on how dry the ink drawing is. And you can apply several layers of wet or dry watercolour for more texture and detail.

This is exactly how the artist has tackled the demonstration here. Traditionally, black or sepia washes are used with pen and ink, but his carefully thought-out use of colour gives a bright, crisp freshness to his drawing. He worked without a preliminary pencil drawing, but you may find it easier to start with a quick sketch.

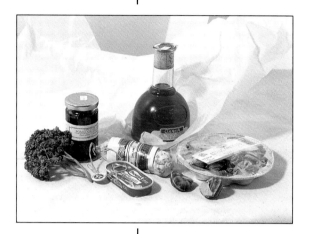

▶ **The set-up** The artist arranged this still life very carefully, even though it looks as though it's been casually tipped out of a shopping bag. Choose objects with pleasing shapes and interesting lettering or labels. Here the olive-oil bottle forms the tip of a triangular arrangement, positioned slightly off centre for a more interesting composition.

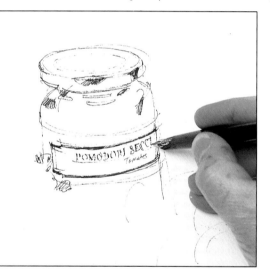

◀ **1** The artist began with the pen, without making a preparatory pencil sketch. Before you make marks on the paper, hold your pen slightly above the paper and 'draw' the image in the air. This helps establish in your head the actual position of the objects and their basic forms and gives you an idea of whether the drawing will all fit on the paper.

Now you can begin. Use the ink slightly watered down for better flow and keep your wrist relaxed and floppy. Hold the pen quite loosely and use fast sweeps to draw light lines for the ellipses of the tomato jar lid. Add small hatched areas to indicate changes of tone. Concentrate on the thick parts of the lettering on the jar, remembering that they also follow the curve of an ellipse. (You could use the pencil to make guidelines for the top and the bottom of the lettering curve.)

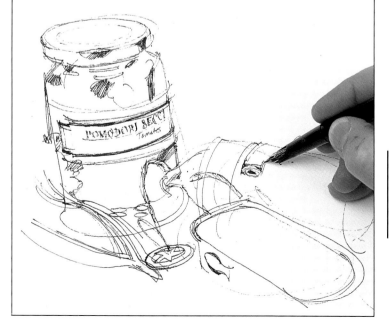

▶ **2** Use fluid, fast-moving lines to draw the objects around the base of the jar. Keep the marks lively and swirling, looking for pattern as well as the negative and internal shapes to help with the accuracy of your drawing. The line is not always solid – the pen moves too fast for the ink to come out as a continuous line so the thicker, darker lines are drawn more slowly.

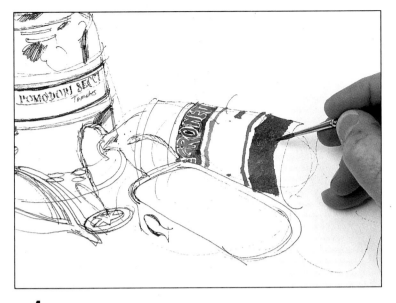

3 The artist varied the procedure by adding colour at an early stage. With your No.3 brush loaded with cadmium red, paint the letters on the salami, feeling your way around them to give an approximation rather than rendering them exactly. Paint the red bands and allow the paint to dry before you wash over the remaining bands with a mix of Winsor blue and black.

4 Indicate any of the objects that you haven't drawn so far with the pen, and strengthen any lines that you feel confident with. Remember, the faster you draw, the fainter the line will be, because the ink won't flow as freely. Once you are sure of the general position and shape of the snail dish, you can start to indicate its contents and label loosely. Don't worry about the number of lines you make – these add rhythm and liveliness. Look at the number of lines the artist has drawn at the end of the salami. What's important here is that all the lines are round and follow its form.

YOU WILL NEED

- ☐ *A 19 x 14in (48 x 36cm) sheet of 190lb (400gsm) watercolour paper*
- ☐ *One round No.3 sable brush; one Chinese brush*
- ☐ *Black drawing ink*
- ☐ *Fountain pen with sketching nib*
- ☐ *Five watercolours: cadmium red, Mars black, vermilion, viridian, Winsor blue*

5 Each object has now been drawn and, with the exception of the labels on the snail dish and anchovy tin, all of the lines are curved. You can exaggerate the lines following a rounded form even if you can't see them, giving pleasing contours to your drawing.

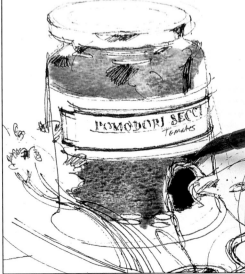

6 Now you can have fun adding tonal work to the jar of dried tomatoes. Mix a wash of black with a touch of Winsor blue to give it a little colour, and fill in the tomato jar. Use the Chinese brush for this – it gives an interesting, uneven texture. Rest the outer edge of your hand on the paper (carefully) if you want to steady your brush a little. Leave parts of the white paper blank for highlights on the top of the jar.

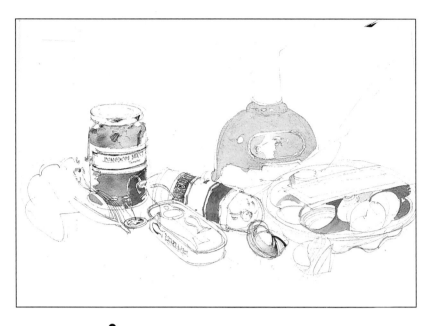

◄7 Add further areas of tone to the olive-oil bottle and the snail dish – dilute the wash used in step 6, and brush over the bottle, tilting the board backwards, if necessary, to stop the wash from running down and accumulating in one place. Give yourself time to consider how dark the wash is going to be and where you want to put it.

Resist the temptation to overwork the picture with tone – let the ink and the white paper work for themselves.

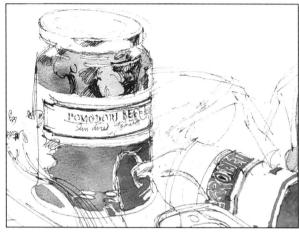

►8 When the wash is completely dry, work over the tomato jar in ink to indicate the shapes within it, using cross-hatching for darker areas. You're drawing a general outline which gives an overall impression. Indicate the tissue paper with a few pen strokes.

◄9 Now you can add more colour. With a strong wash of warm red – cadmium red or vermilion – fill in the anchovy tin and the stripe on the snail dish label. Use the No.3 round brush and keep the colour bright and clear by using fresh water for mixing the wash.

Use a second wash for the darker shapes of the reflections in the olive-oil bottle. Keep the shapes sharp to convey the hardness of the glass and keep the white highlights clean. A further wash on the snail dish helps to locate the label. Add two lines of viridian to the salami label.

►10 With tight, curly scribbles of your pen, work up the foliage of the parsley. Look at the rhythm in the lines of the parsley stems and draw them using long sweeps of ink. Try to reflect the tree-like character of the parsley.

The final loose washes, brushed on with the Chinese brush, ensure that the still life doesn't look as though it's floating around in space. A grey wash underneath the parsley indicates the form (the light is coming from above); a thin wash of black on the tissue paper helps to locate the objects on the table.

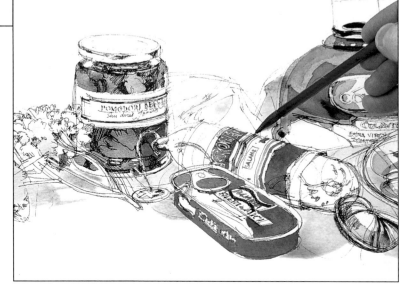

▶ **11** Paint the shadow on the ring pull in a single line with the No.3 round brush and a dilute black wash, holding your hand away from the paper by balancing it with your little finger.

▼ **12** The finished work shows a lot of restraint. There's not too much colour, which means that the freshness of the pen-and-ink lines have been retained. The artist has successfully combined two different media to create a crisp and lively drawing – with more than a hint of the warm flavours of the Mediterranean!

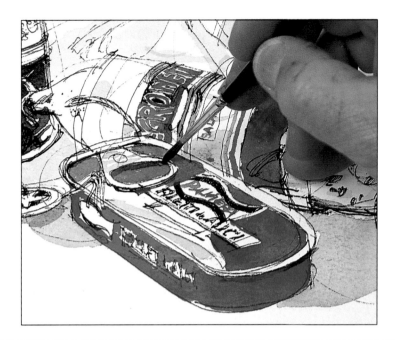

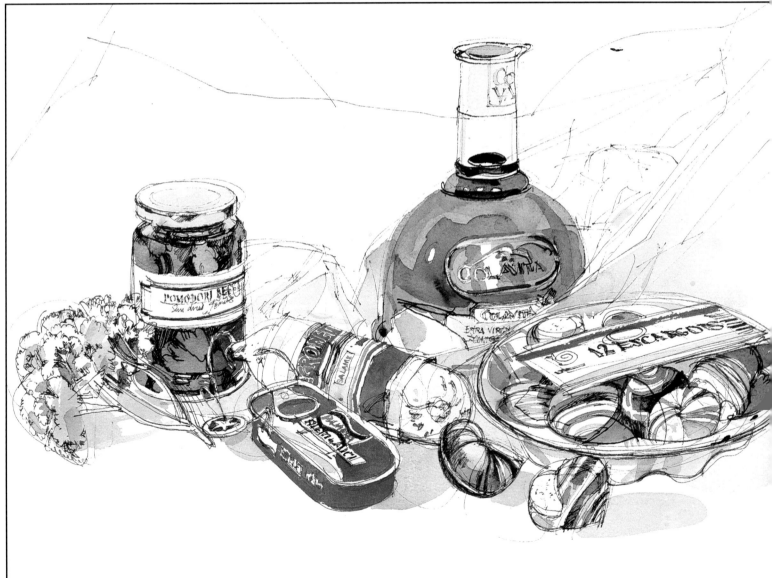

Ballpoint pens

The sheer number and range of styles of ballpoint pens available mean that it is well worth your while to try out a sample of them – the results may surprise you.

There's no denying that ballpoint pens have often been regarded as the poor relations of the drawing world. Compared with the subtleties of other types of pens, the many different grades of pencil and graphite and the boldness and sheer verve of charcoal, ballpoints may well appear to lack character. This is in part due to their reputation for blobbing and smearing, and to the fact that in the early days, there was very little variety in nib widths. Mainly, though, ballpoints were criticised for their tendency to produce a line that was too constant and 'wiry' in character.

However, with modern technology, and the development of the rollerball pen, much of this has changed. Many ballpoints no longer gather messy blobs of ink at the point and there is a vast and growing range of nib sizes and points to choose from.

The pros and cons

A ballpoint pen is exactly what its name suggests – it consists of a reservoir of ink inside a plastic or metal casing with a head containing a metal ball that ensures a regular,

▲ Rollerballs have a free-flowing, 'wet' ink line. There are many different varieties available, with thick or thin nibs and water-soluble or waterproof inks. Some have clear plastic casings so that you can see how much ink is left.

◄ This is a selection of the large number of ballpoints available. The lines that they make vary slightly from pen to pen, so try out a few to see which you like best. And remember to check the prices before you buy – they vary considerably.

Go for colour

Although most of the brightly coloured ballpoint inks are, unfortunately, fugitive, it's fun to try drawing in some of the dozens of colours that are available. It's an appropriate pen for drawings made for reproduction purposes, and for sketches which are to be used fairly soon as references for a painting or charcoal drawing.

If you want to keep drawings and sketches done in coloured ballpoints, then use a sketchbook, keep them covered and store them in a drawer away from direct sunlight.

controlled, constant flow of ink as you write. Being made of metal, the ball doesn't deteriorate, roughen or wear down with use – it draws in precisely the same way each time.

One crucial distinction to make within the 'family' of ballpoints is that between the ordinary ballpoint and the rollerball. The ordinary ballpoint has a slightly shiny, viscous, usually waterproof ink that dries quickly on the page, but can sometimes form blobs that take a long time to dry and can smear. The rollerball, by contrast, comes with ink that is much more like that in a

Different pens, different effects

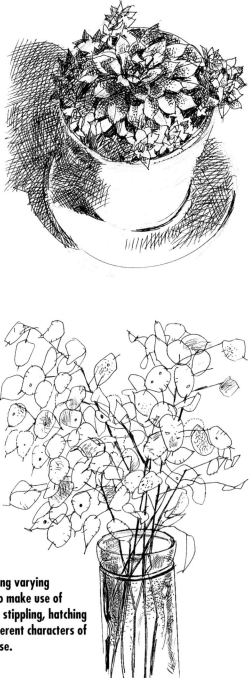

▲ A medium ballpoint pen describes the line of the contour of the shell and the hatched tones of the darker interior.

▼ Lighter or heavier pressure gives you a range of tones from just one ballpoint. A combination of fine grey and black lines creates the spiky, feathery look for this chestnut.

► Ballpoints lend themselves very successfully to the classic technique of building-up a range of tones by hatching and cross-hatching lines. This has been done with a fine ballpoint pen.

▲ Fine line drawing and stippled detail are enhanced by subtle shading on the underside of the sea urchin shell – created simply by rubbing the water-soluble ink with a damp finger, then drawing over the toned area.

► A combination of stippling and fine line work with a rollerball pen on top of watercolour brings charming detail to this conker in its shell.

► A quick way of depicting varying textures in a drawing is to make use of different techniques. Here stippling, hatching and shading show the different characters of seed heads, stalks and vase.

cartridge pen or fibre tip – it writes 'wet' and very dark, dries quickly by evaporation, and does not create blobs.

The virtues of ballpoint pens are many: they are inexpensive, easily replaceable, and they are quicker and easier to use than any pen that requires to be loaded with ink as they have a ready supply. They offer a useful alternative when considering using fibre-tip pens for a drawing, and although they are not as accurate as technical pens, they can sometimes take their place.

The same reasons that make ballpoints so popular in schools and offices also make them useful for sketching and drawing: they are highly portable, they can give consistent marks with great smoothness of flow, their ready supply of ink is long-lasting, they require a gentle, even pressure and they produce a clear, positive mark on most types of paper.

Ballpoints can be used to produce both an even, controlled line, and one with a certain amount of variety, depending on the amount of pressure that is applied to the nib.

When selecting a ballpoint pen, you might want to bear in mind a practical point – the removable tops have an irritating tendency to fall off and get lost, so a click-action model might be a more convenient choice, particularly if you are carrying your pens in your pocket.

The main disadvantage of ballpoints is that they are not permanent, even though some of them have the word written on the barrel of the pen.

Tip

Ballpoint ink stains
One problem with the viscous ink used in most ballpoint pens is that it is difficult to remove – both from your hands and from clothing. In the early days these pens often leaked, causing problems if kept in the breast pocket of a jacket, for example. If you get ballpoint ink on your hands, wash it off at once with soap or detergent; if you get it on your clothes, remove it with a proprietary cleaner. Also, keep a piece of kitchen paper handy when drawing and use it to wipe the point of the pen – this helps to prevent blobbing and smearing from a build-up of ink on the nib.

▲ Some ballpoints come supplied with their own erasers – giving you free rein to rub back or wipe into the drawing to create some very subtle tones as well as sparkling highlights.

► Ballpoint gives you a great opportunity to mix media for exciting effects. Here slightly water-soluble ballpoint establishes the main outlines, while water-soluble pencils applied on top provide colour and vibrancy.

◄ Most ballpoints contain waterproof ink, and are excellent for fine, clear, hard-edged line drawing – which can then be given depth and solidity with a tonal range of watercolour washes.

▼ You can use water-soluble ballpoint to draw wet-into-wet – as here, where the pen lines blur slightly into very wet watercolour to give a delightful soft-edged look.

Drawing and sketching with ballpoints

Ballpoint pens work at their best for small-scale drawings. They don't lend themselves to half life-size figure drawing, for example. Once you have chosen a scale to suit, and subject matter that lends itself to a linear approach, ballpoint pens can hold their own well against both pencil and pen and ink .

Some inks are waterproof (often labelled 'permanent') and some are water-soluble. With the water-soluble type, you can smudge the marks with a little water, using your finger or a brush, for soft, blurry effects and tones. Combining ballpoint pen marks with other media gives some attractive effects: use them with different combinations of watercolour washes, soft pastels or coloured pencils.

Ballpoints work well on most papers. The marks you get vary greatly from pen to pen. Some, especially the rollerballs, produce a very dense, strong black line; the standard ballpoints produce a rather greyer mark. All have great staying power, which sustains the line well, producing a consistent black mark. The line is precise and incisive – you can do quite fine linear work and hatching. Ballpoints are good for scribbling and excellent for stippling, and they come into their own for rapid notes where pencil or charcoal would smudge.

Nibs come in various widths, from very fine to very thick. Experiment to find the ones you like, then keep a few handy at all times. Some pens come with several refills, which means you can use the one that suits you for many years.

▲ Here is a drawing using a modern tool in a classical way. Although pens are most often associated with linear work, by cross-hatching you can create tonal drawings like this one.
'Pensive Model' by Stan Smith, ballpoint on paper, 11½ x 16½in (29 x 42cm)

Ballpoint and wash

Ballpoint pens are capable of a surprisingly sensitive range of marks, and combine well with tonal washes, which bring out the various hues that make up the black ink of different brands.

Although ballpoint and rollerball pens don't tend to have the flexibility of dip pens and pointed nibs, you can develop a ballpoint drawing to quite an advanced degree by making use of subtle, considered shading and hatching. By exploiting the differences between pens with waterproof ink and water-soluble ink (in particular, rollerballs), you can achieve some interesting smudgy, soft effects. Add a watercolour brush to your equipment and you can include wash effects in your drawing as well. (A side-effect of this is that some water-soluble black ballpoint inks are greyish in tone, while others are brown, blue or purple, and combining more than one in a drawing gives a fascinating range of 'monochrome' tones.) With a little practice, you can develop an attractive, stylish wash-and-line technique.

Since the nib of a ballpoint varies from pen to pen in width and smoothness, choosing a range will help you achieve a great deal of variation in stroke. Even if you don't want to use wash techniques in your drawing, you can develop shadow and tone in an entirely graphic manner with cross-hatching, either in fine, thin,

delicate lines placed close together or in broader, more generous strokes.

The artist started with a sketch of bathers in a pool (below), using layers of hatching to develop the tonal depth. But look closely at the bottom right to see where the artist started to experiment with smudging out the line with water. This sketch led to the full-scale wash-and-line drawing of the bathers that follows.

► This is one of a series of studies made by the artist on the subject of bathers in a secluded pool in Provence. Varied cross-hatching, subtle grey washes and areas of fine detail with a fine-nibbed ballpoint show form, depth and texture in a lively, yet controlled way. An attractive drawing in its own right, this also makes a study for a fully resolved oil or watercolour painting.

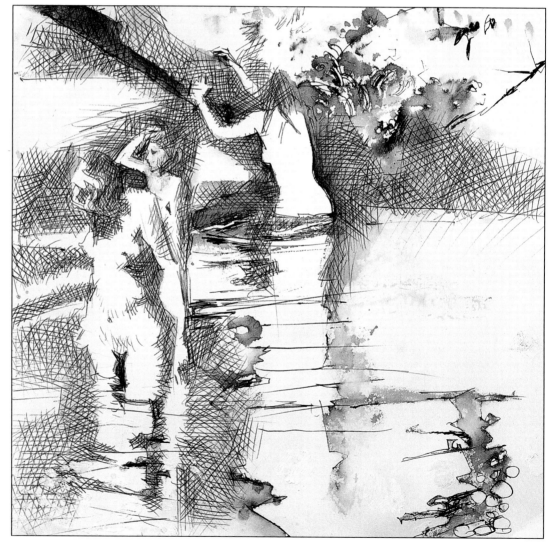

Bathers: preliminary study

It's always a good idea to begin by trying out your ballpoints in some speedy sketches before you start a drawing. Various pens have different characteristics, so you need to be thoroughly familiar with the ones you have. For the sketches below, the artist used a fine-quality, medium-nib, rollerball pen with water-soluble black ink that produced a rather attractive bluish-purplish wash. His aim was to achieve a quick series of studies which could be developed into a more sophisticated drawing – or, indeed, form the basis for a painting.

► Sketch the main outlines of the figures and the landscape with the ballpoint. Develop the darker shadows with quick strokes and scribbles. Don't worry about details – the aim here is to locate the figures and catch as lively and animated a sense of the scene as you can.

◄ Moisten your finger a little and smudge any lines where you want more expressive tonal shading. You'll be able to work out quite quickly how much moisture you need to smudge the ink; in some cases a small amount of water and a brush can push the smudge into a finer wash.

If you want to increase the tone for heavier shadow, scribble or hatch over the wash with the ballpoint to give additional depth.

► In the final sketch the main outlines are all in place, as are the principal tonal areas. Although this is nothing more than a ten-minute sketch, there is plenty of information to help you develop the drawing further. To gain more confidence, try doing several such sketches until you have the 'feel' of the pens you are using.

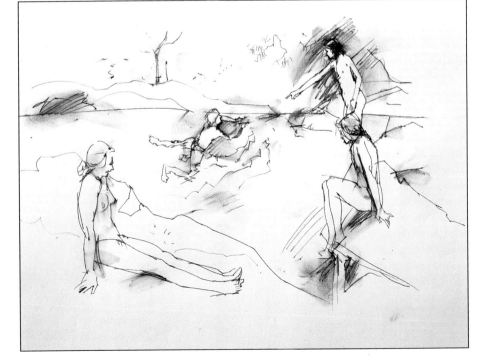

Bathers: pool in Provence

The composition for this drawing is taken from an ongoing series of quick ballpoint sketches of bathing figures (including the ones shown on the two previous pages). The idea was to develop the sketches into a drawing where several figures are linked together by a light monochrome water-colour wash.

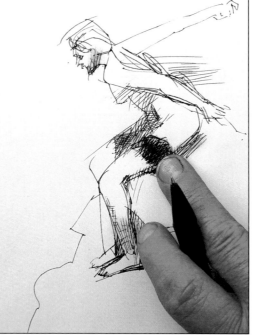

▶ **1** Outline the two main figures in the drawing (note there will eventually be three in all). Use the medium-nib water-soluble ballpoint, drawing with quick, fluid lines, then put in areas of cross-hatching for the shadows – lightly on the torso and around the ankles, and heavier on the thighs of the girl about to dive, and on the head, back and around the arms of the first swimmer.

Use your finger, slightly moistened, to smudge areas of cross-hatching where you want more tonal depth.

◀ **2** Start to extend the ballpoint-ink shadow, first scribbling in some areas of deep tone with the brownish ink pen. Use a wet brush to push the diluted ink out from the swimming figure. Try to maintain the outline of the figure in quite clean, crisp lines. The aim is to make the bather stand out from the watery background.

(Note how the brownish tone of the ink from this pen gives more depth and variety – even at this early stage in the drawing.)

▶ **3** While the wash is still wet, use the same pen to cross-hatch over any areas needing extra depth – in front, behind and under the swimmer. The ink blurs on the edges to give a softened tone.

Note that using ballpoint over washes creates different textures according to which type of ink your pen has: waterproof ink has a different quality that will be used later on to emphasize certain areas.

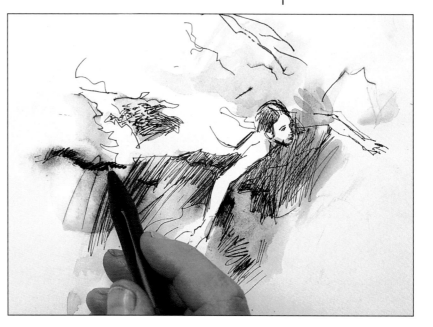

YOU WILL NEED

☐ Two 11 x 14 in (28 x 35cm) sheets of good-quality smooth drawing paper

☐ Four (or more) black ink ballpoint pens: the artist chose one medium-nib pen with water-soluble ink, one fine nib pen with permanent ink, one pen with brownish water-soluble ink and one fine-nib rollerball pen with ink that is briefly soluble while it is wet – but you can make your own selection to suit yourself

☐ One No.5 round watercolour brush

☐ Two jars of water

☐ One tube of Payne's gray watercolour paint

☐ One tube of titanium white gouache paint

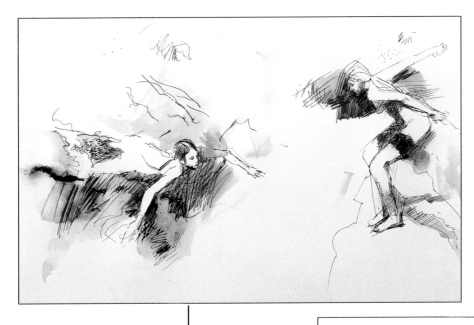

4 Extend the areas of shadow around the head and behind the back of the diver – use hatching for this. Dilute the ink to emphasize the shadow, but don't add too much wash.

At this stage, the artist has developed the two dominant figures to quite a high degree, and only used the water-soluble ballpoints, with the watercolour brush and water to create the tones. He was composing the picture as he progressed, using different figures from various different sketches. Now he decided to put in another swimmer to link the other figures and create a sense of perspective.

5 As soon as the third figure is added, its scale gives you an immediate idea of perspective. Outline the shape of this figure with just a few sketchy strokes, then link all three bathers with a series of light washes in Payne's gray – these cover the entire water area. Paint in expressive, roughly circular strokes. Apply cross-hatching in areas where you want a darker tone, and use looser, scribbled lines for areas of mid-tone.

The contrast between the linear ballpoint elements and the soft washes is now starting to help the picture develop rapidly from a brief sketched outline into a more complex drawing.

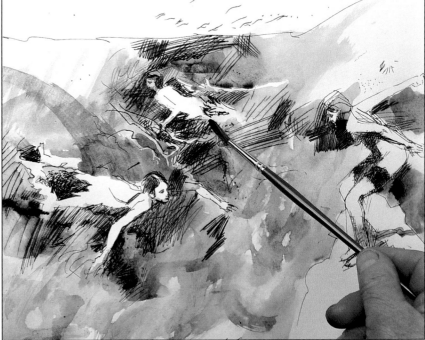

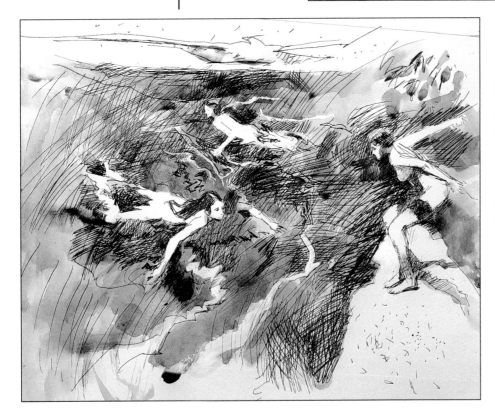

6 Build up the water around all three figures with the medium-nib pen. Cross-hatch in several different directions to achieve a varied texture, using quick strokes that help the picture remain fresh and lively.

Apply very dilute white gouache with the watercolour brush to highlight a few areas of ripples in the water.

The artist wanted to make corrections to the faces of the two swimming figures. He used white gouache to paint out the features that he intended to amend. Later, he drew over the white in line, bringing these areas back into the overall line-and-wash technique.

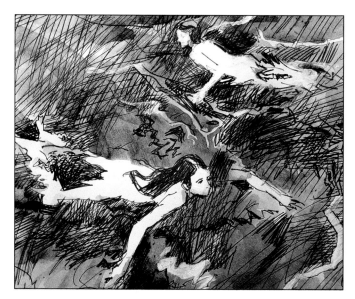

◀ **7** This close-up of the figures shows how all the different hatching marks work together to create texture and tonal variation in the water. The varying qualities of the ink from each pen give an interesting range of lines from blurred to very crisp – this is where your previous practice sketches, made with a variety of different pens, will stand you in good stead. Note the careful application of a little white gouache on and around the figures.

▶ **8** Use the fine-point pen with the permanent ink to draw in the tiny details of the faces. These lines must be in permanent ink so that they remain crisp and sharp, and won't blur with additional washes.

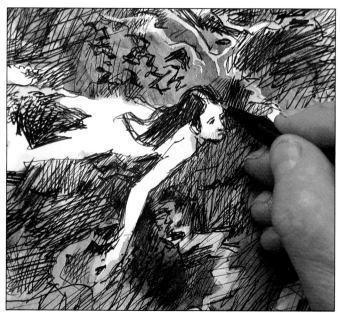

◀ **9** Use the fine-nib rollerball pen (which produces a rich, dark, wet line) to intensify the background around the faces with hatching. This can be softened – while the ink is still wet – by smudging immediately with your finger or with a watery wash to blur the lines. Note that the artist has repeatedly scribbled over the surrounding water to give more texture and depth. The various angles and marks create an almost etched effect.

▶ **10** Go over the entire drawing with the fine-nib rollerball pen, adding firmer lines and smudging for tone. Make sure that the figures stand out and that the shadows are dark enough to recede to create perspective. Smudge and intensify the shadows to create lively contrasts.

▶ **11** Finally, add a last touch of additional texture to define the edge of the bathing pool. Make random dotted marks with the medium-nib water-soluble ink pen to indicate the different surface of the land and to define the horizon. This brings another texture to the drawing and marries well with the broad, fine, linear or smudged range of marks already well integrated into the picture.

▼ **12** Although the final image is quite sophisticated, the whole drawing took very little time to complete – about one hour.

This is quite important if you want to maintain liveliness and freshness – a ballpoint drawing that takes too long is likely to look laboured and flat. Here there is an ongoing 'dialogue' between the crisp, varied hatching and the softer, flowing greys produced by the washes and smudges.

Although this is a black-and-white drawing, a great deal of extra interest comes from the subtleties in tone so noticeable between the bluish and the brownish inks. Aim to buy a range of different pens, then find out what they can do.

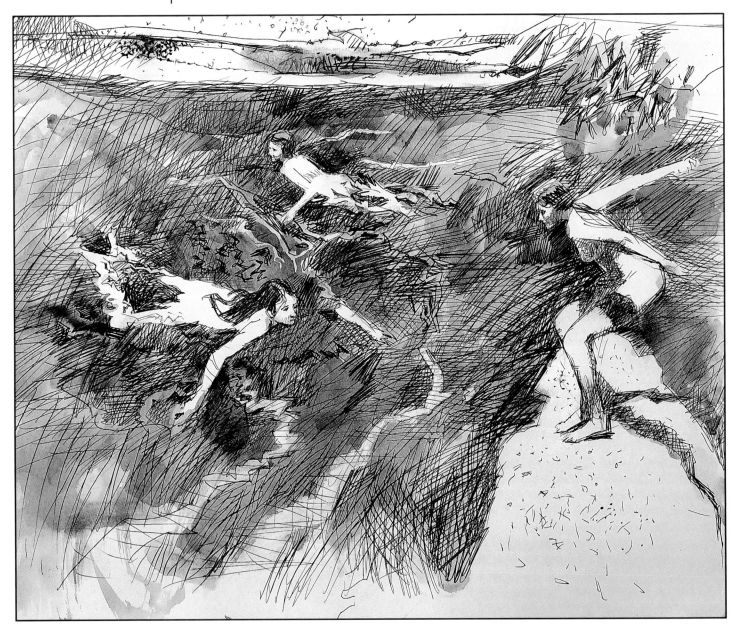

Ballpoint and colour wash

Ballpoint pens work well with watercolour washes, creating effects similar to traditional dip pens. It is interesting to exploit the different qualities of both waterproof and water-soluble pens.

For the picture overleaf the artist chose an unusual but very successful combination of media. His subject – a vase of freesias – demanded a colourful interpretation. He also needed plenty of scope for line drawing to pick out the textural variations between petals, buds and glass. Watercolour provided the vital element of colour; for drawing, he opted for ballpoint pens.

As with traditional line and wash, you can draw into a wet wash or, conversely, make a crisp line drawing and work over it with colour washes, blurring the lines a little (in this case, you'll need a ballpoint with water-soluble ink). If you want to retain the crispness of the pen lines, you'll need a ballpoint with permanent (waterproof) ink. This allows you to wash over the image without blurring it. To add more interest, try making use of the different effects of both these line qualities in the same drawing, as the artist did in the following demonstration.

Ballpoints are relatively inexpensive, so buy a variety and experiment with them. You may wish to make use of the slightly different shades of black ink available in ballpoint pens – some blue-black, others brown-black. Try the exercise below before you start a picture.

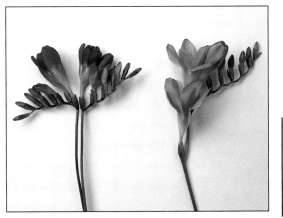

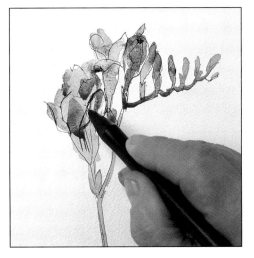

◄ Try this exercise The artist selected these two bright and colourful freesia sprays to illustrate the different effects that you can achieve with permanent (or waterproof) ink and water-soluble ink.

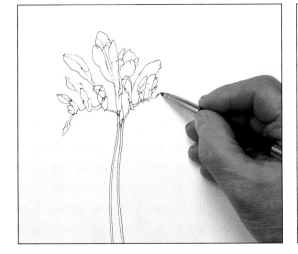

▲ For a precise, controlled image, use a ballpoint with permanent ink and start with a fine outline drawing, as the artist does here for the red and yellow spray. Spend time on your drawing, looking craefully at the subject to try to capture its own particular shapes and curves.

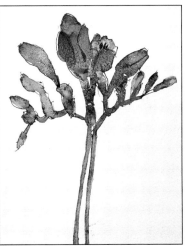

▲ Once the ink has dried, use some watercolour washes to give your outline drawing form and solidity. Note that the pen line remains fixed. For a clear, distinct image, paint within the outlines.

▲ For a rather different effect, paint in the basic shape of the subject with washes of colour. Then draw straight into the wet paint with a water-soluble ballpoint pen. The softened lines create a loose, informal style which is most attractive.

An arrangement of freesias

At first, this rather full arrangement of flowers seems quite complex, with its tangle of stems distorted slightly below the water line, and the profusion of buds and flowers. With so many details, it's difficult to know where to begin.

The artist started by outlining a few sprays loosely, then concentrated on building their forms with colour washes before moving on to other sprays around the arrangement. As he progressed, he varied his technique, contrasting crisp and blurred lines, and washes of colour.

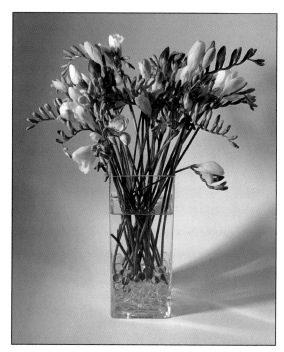

YOU WILL NEED

- [] A 22 x 15in (56 x 38cm) sheet of 140lb (300gsm) NOT watercolour paper
- [] Two ballpoint pens: a permanent-ink fine-nib and a water-soluble medium-nib
- [] Watercolour palette
- [] Two jars of water
- [] A No.4 round synthetic brush
- [] Nine watercolours: cadmium yellow, yellow ochre, cadmium orange, crimson lake, scarlet lake, cobalt blue, sap green, raw umber and black

▲ **The set-up** The artist liked these beautiful freesias for the contrast they provided – delicate petals, firm buds and long, streaky stalks. For more contrast in shape, he filled the base of the vase with a few glass marbles. To avoid any background details, he placed the arrangement in front of a sheet of plain white paper.

◄ **1** Using the fine-nib, permanent-ink pen, place your subject with a few loose outlines which will guide you through the picture. (If you don't feel confident about your pen marks, work lightly with a pencil, going over the lines in pen when you're satisfied with them.) Make quite sure at this stage that the arrangement fits well within the confines of the paper – you don't want the flowers disappearing off the top of the sheet.

▶ **2** Concentrate first on one particular spray. The artist focused on a spray with yellow flowers and many buds, situated towards the right side of the bunch. Paint in the basic shapes of the buds with quick strokes of sap green. Draw into the wet paint, adding detail to the buds with the water-soluble ballpoint pen.

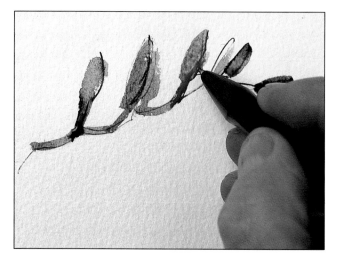

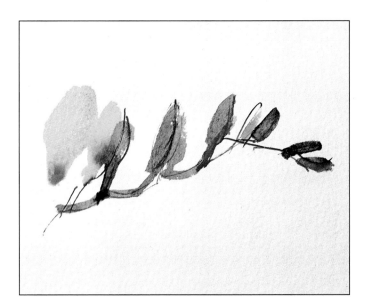

◀3 Move along the spray to paint the yellow flowers. Load your brush with cadmium yellow and make loose, full brushmarks to suggest their shapes.

The artist skilfully used the remnants of green on his brush to indicate the base of the petals, which you can also do by stroking some dilute sap green into the yellow paint.

Put in more sprays on the right side of the picture, painting and drawing some, and leaving others just painted.

▶4 Strengthen the spray of buds to the left with a permanent-ink pen to add a different element to the picture. Then paint in the stems, using the thin point of the brush to control the lines. Use different dilutions of sap green, and paint some stems with strong cadmium yellow to add brightness.

Loosely paint the marbles – although they are clear, use green to show reflected colour.

▼5 Add shadows to the stems. Work loosely over some outlines with the water-soluble pen, coaxing the ink to run a little. For contrast, draw some outlines heavily with the permanent-ink ballpoint. Paint shadows on the base and side of the vase with dilutions of black.

Paint the surface of the water with a very dilute wash of yellow ochre. Work thoroughly over the water-soluble pen marks, encouraging them to blur.

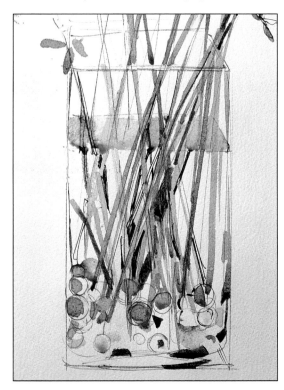

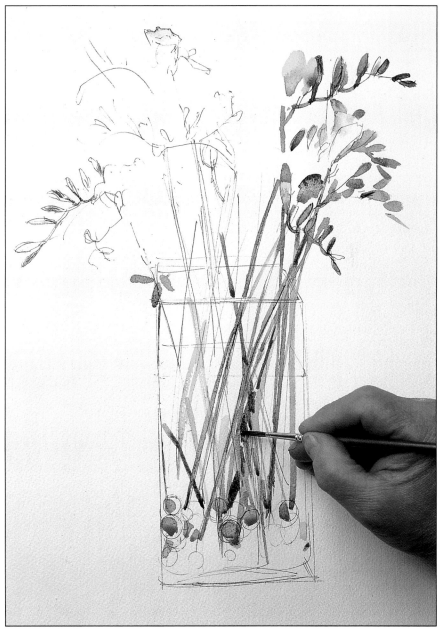

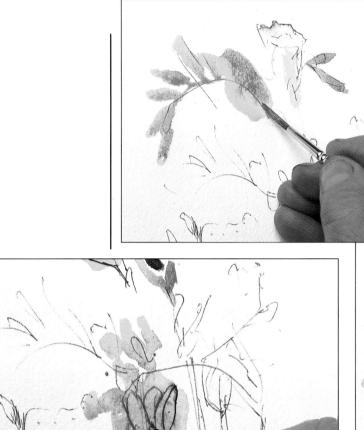

6 Work around the edge of the arrangement, building up the main sprays. Use different techniques to add interest. Here, the artist painted over his initial outlines with washes, working wet into wet to capture the colour and tonal modulations. This created a soft effect, which contrasts with the strong marks of the permanent-ink fine-nib pen (see below) which the artist added on top of dry paint. Note how he doesn't always keep to the shapes he made with the paint, but re-draws the flowers and buds.

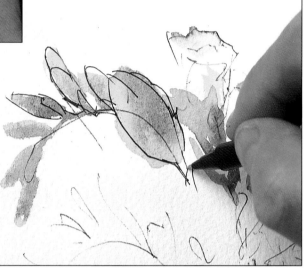

7 Here, the artist drew into very wet paint with the water-soluble pen so that the ink blurred immediately, creating a different effect from the pen marks in the previous step. This technique produces lines that are less defined – useful for loose details around the flowers.

(The artist used two water-soluble pens for variety of line. You may prefer to do the same to create more interest in your own picture, but one water-soluble pen will do.)

8 Having established the main outer sprays, start to move towards the centre of the arrangement.

Brush in some of the brightly coloured flowers – load the brush with plenty of paint and make quite loose, soft strokes, overlaying colours wet into wet to avoid hard edges. Vary the dilutions and colours of your washes for more creative results. Don't concern yourself too much with details since the idea is simply to indicate the broad mass of blooms.

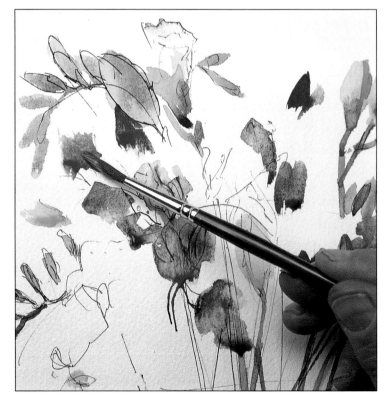

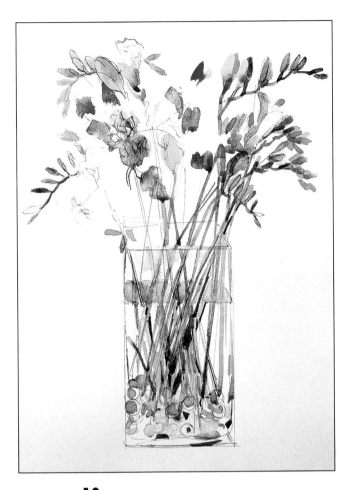

◀ 9 Stand back from your picture to assess its development. The loose, informal style works well with the bright colours, making for a lively, pleasing image. You now need to build up shadows and work further into the arrangement to develop the internal mass of flowers.

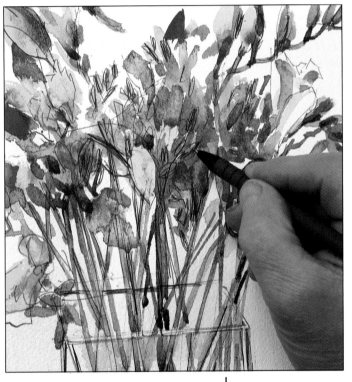

▶ 10 Build up the flowers with loose strokes of colour, working into some with the water-soluble pen, and into others with the permanent pen to emphasize the outlines of buds, leaves and flowers. Leave a few as simply painted shapes.

Use your pens to make shadows with some fine hatching – as well as adding another texture, this also endows the picture with some rich, dark tones.

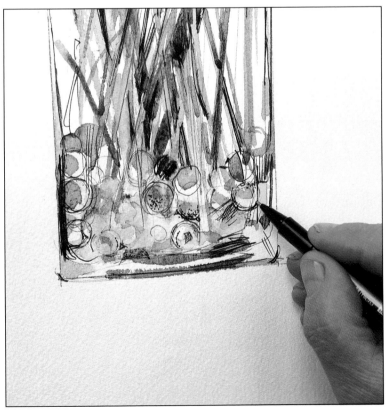

◀ 11 Turn your attention to the marbles at the base of the vase. You need to make this area a little more 'weighty' to balance the energetic burst of the flowers.

Paint more watery shadows, this time with a very dilute mix of black, green and a touch of blue. Then use the permanent-ink fine-nib pen to add some dark tones. Hatch in places, and use a series of small dots to pick out the curved outlines of some of the marbles.

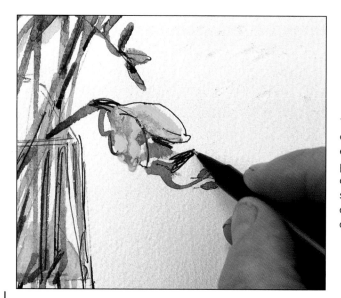

Tip

Drawing details

Ballpoints come into their own when used for detailed drawings, and when, as here, their crisp, fine lines give a touch of definition to bold colour areas. Even if you smudge them, your marks will never be broad, so make sure that you choose an appropriate subject. Also, avoid working on too large a scale for the same reasons.

◄**12** Make the final adjustments. The artist had earlier chosen to omit this particular spray, then decided at the last minute to include it, since its low position and its angle fill a gap and add an asymmetrical note.

▶**13** Ballpoints used with watercolour washes allow you to work at great speed, and are an excellent combination for quick studies as well as finished pictures. Here, the speed adds a delightfully vibrant touch to the already resonating colours and energetic, varied linework.

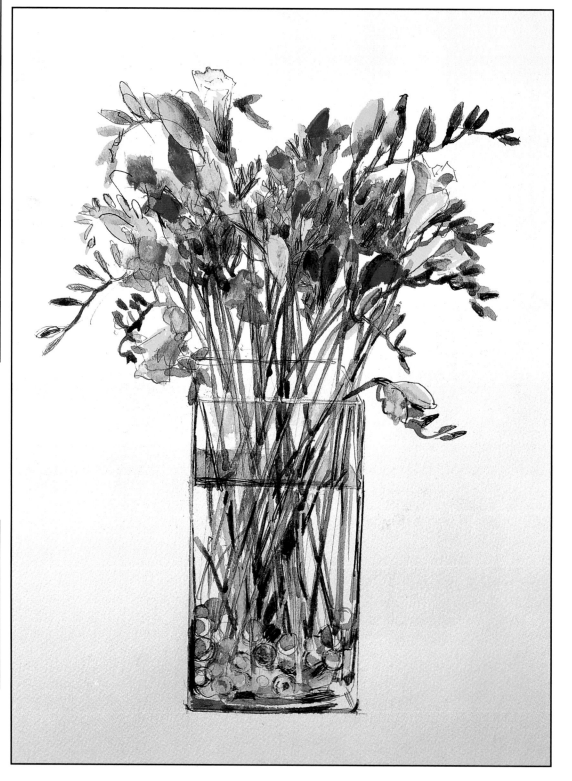

Coloured inks

Coloured drawing inks are available in a brilliant range of colours for use with both pen and brush. Colours can be mixed on the palette, and, owing to their transparency, on the paper.

Coloured inks are a striking and versatile medium. Even when several washes are applied one on top of another, they allow lots of paper to show through, making them perfect for capturing translucent colour. At the same time, inks – being liquid – allow you to work with a pen to achieve linear detail.

The disadvantage of coloured inks is that they aren't lightfast, being made from dyes rather than pigments. Manufacturers usually claim permanence only for the black and the white inks, and sometimes also the metallic colours – gold and silver.

Inks, therefore, are an excellent medium for illustrators who have their work reproduced, but they are not ideal for artists who want to frame and hang their work. Liquid acrylics are a good, lightfast alternative – they are very fluid so they handle much like inks, and they produce equally brilliant colours.

Setting up

The artist took some time arranging the objects for this still life. A dishcloth with red stripes in the foreground helps lead the eye into the picture. And the diagonals created by the stripes provide a striking contrast to the verticals of the bottles.

He began the drawing in canary yellow ink. It's always best to start diffidently in very thin ink, preferably in a fairly pale colour, such as canary yellow – you can make bolder marks later. Losing the pattern in one area will put everything else out of position.

After completing the canary yellow drawing, the artist strengthened the contours of the drawing with brighter, darker colours. Always test these darker colours on the side of the paper before committing them to the drawing. Ink is a powerful stainer, and mistakes are almost impossible to rectify.

The next step was to put in the washes. The artist created deep colours by laying several washes on each object. Finally, he returned to the pen to put in some of the more intricate detail.

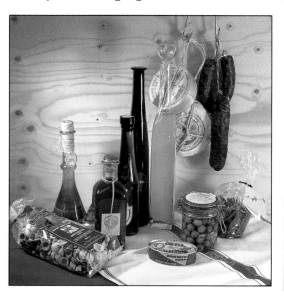

◀ **The set-up** For this colourful arrangement, the lighting was provided by two lamps. One, on the left, was directed at the wooden backdrop so that light bounced back through the bottles, creating wonderfully rich, translucent colours. The other, on the right, created long, eye-catching highlights on the black and red bottles.

▼ **1** Draw all the objects in a very thin canary yellow. Look, in particular, at the negative shapes. Keep dipping your pen in the jar of water to keep the ink very thin. Once everything is in place, work up the drawing in more appropriate colours: sunshine yellow for the oil bottles, vermilion for the sausages, a mix of vermilion and orange for the vinegar bottle and a very dilute nut brown for the olive jar.

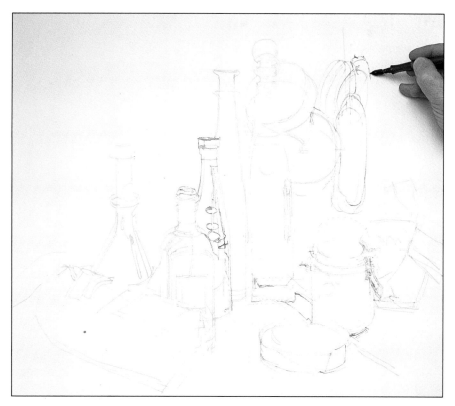

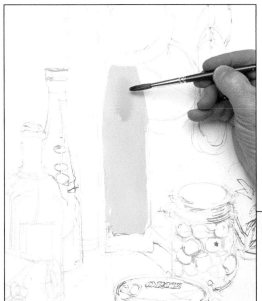

2 Continue building up the drawing, using a mix of apple green and peat brown for the olives. Use deep red for the sardine tin.

Then begin on the washes for the bottles with the No.8 brush. Apply sunshine yellow with touches of vermilion and apple green on the tallest bottle.

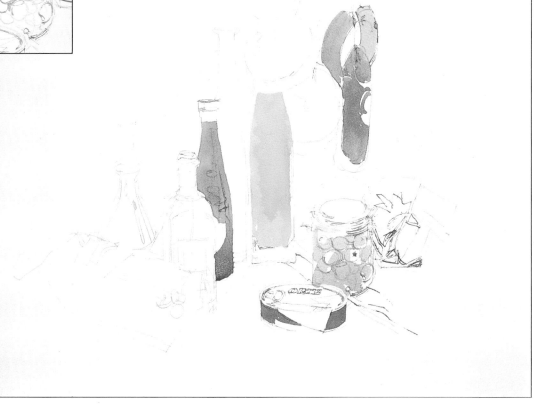

YOU WILL NEED

- ☐ *32 x 22in (80 x 56cm) sheet of 190lb (400gsm) watercolour paper*

- ☐ *Two round brushes: Nos.3 and 8*

- ☐ *A round hand lettering pen (preferable to a mapping or drawing pen – it holds more ink and is less scratchy)*

- ☐ *Two jars of water*

- ☐ *A watercolour palette for mixing the inks*

- ☐ *Sixteen Winsor & Newton coloured inks: canary yellow, sunshine yellow, orange, vermilion, carmine, crimson, deep red, blue, ultramarine, emerald green, apple green, violet, purple, peat brown, nut brown and Indian black*

- ☐ *Craft knife*

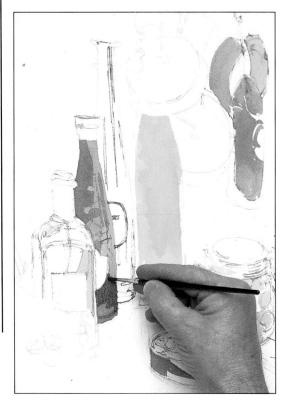

3 Move on to the preliminary washes on the other major objects with the No.8 brush. For the olives, use apple green with a touch of black; for the sausages, vermilion and peat brown; for the vinegar, canary yellow and orange; and for the sardine tin, vermilion. Wait until the ink is dry before reworking the washes so that you attain crisp edges.

4 Using the pen again and black ink, draw in the black bottle, including the label and long, thin highlights. When you come to paint the wash on this bottle, these areas should be left as white paper.

Build up the richness of the vinegar bottle by adding a mix of vermilion, orange and purple on the darker tones with the No.3 brush. (When working around the label, you may find it helpful to support your painting arm with your other hand.)

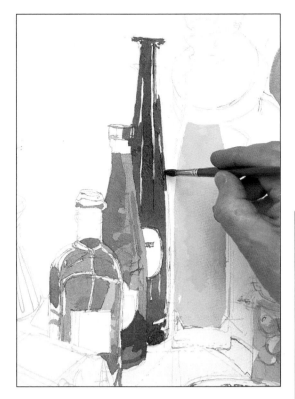

◄5 For the body of the olive oil bottle in the foreground, use a mix of nut brown and apple green with touches of deep red and sunshine yellow. For the paler tones, use just nut brown and sunshine yellow. On the black bottle, use a mix of black and emerald green – making sure that you don't go over the highlights that you drew in step 4.

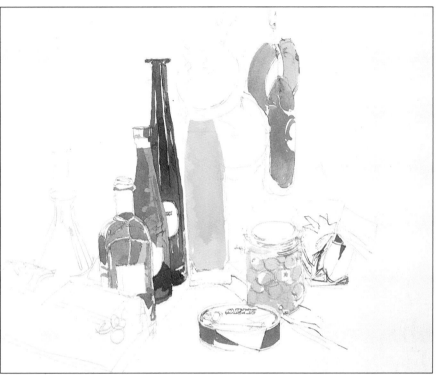

►6 Step back and review the picture. Most of the major objects are blocked in – now it's a question of adding detail with the pen and working up the washes on the bottles to capture the subtleties of the colour created by the back-lighting.

▼7 Add the bold stripe on the dishcloth in vermilion with the No.3 brush. Don't try to paint the whole cloth – this will complicate the picture.

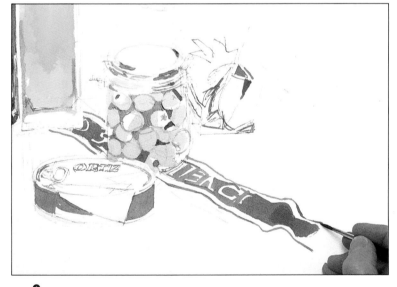

►8 Continue building up the washes to capture the rich depths of colour. Also, pick out more details in pen. Add darker tones on the vinegar bottle with a mix of purple, orange and a little black. For the string of cherries inside the bottle, use a mix of carmine and crimson. Also apply this mix for the wax seal on the small olive oil bottle. Fill in some highlights on the black bottle with blue and emerald green. Use a mix of apple green and canary yellow for the top of the salad dressing flask on the left, and a mix of emerald green, canary yellow and a little nut brown for its base.

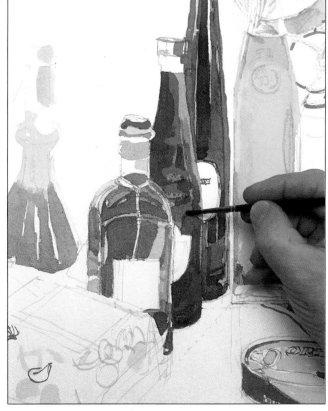

▶**9** Fill in the peppers with a wash of vermilion and purple, varying the strength of the wash to attain some modelling. Overlay some peat brown for the deepest shadows.

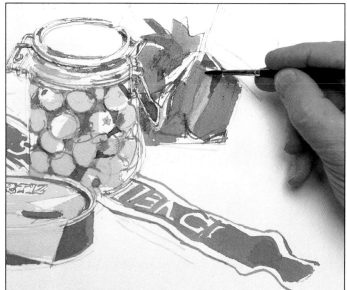

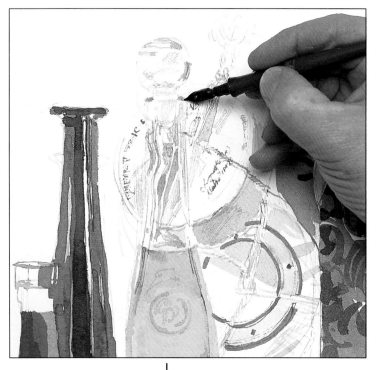

◀**10** Paint the pattern of the sausage meat with a mix of strong vermilion and peat brown. Return to the pen to draw in some details. The cheese box has been distorted by the clear glass at the top of the tall bottle and has created some very interesting patterns. This detail has very little colour so use a cool grey, mixing it in a half-and-half ratio of black ink and water and adding a hint of apple green.

▼**11** Add some blue to the grey mix you used in the previous step to draw in the cellophane wrapper for the peppers and the string wound around the top of the salad dressing flask. Use the No.8 brush to add a pale wash of nut brown to the top of the flask to serve as a shadow.

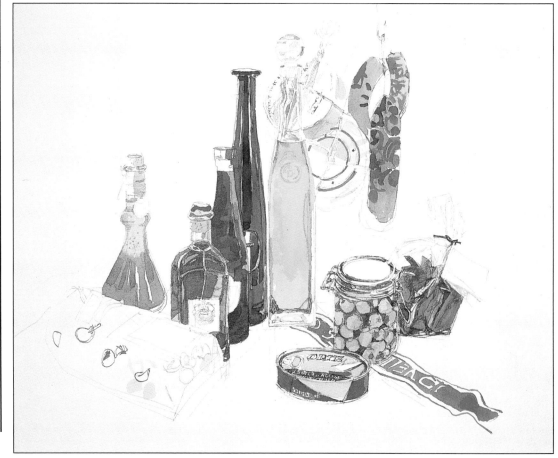

► **12** When drawing the pasta shells, the secret is to respond to the basic shapes, not to follow slavishly every fold and detail. Don't fill the area with colour either – use loose hatching and leave lots of paper showing through. Draw in the label on the packaging in blue ink.

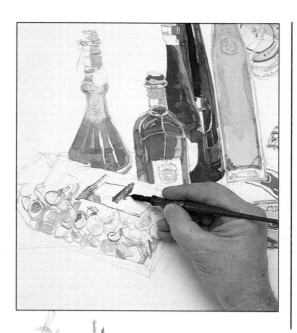

◄ **13** Using the No.8 brush, sparingly wash canary yellow with a little nut brown over the shadows in the background to prevent the objects appearing to float in white space.

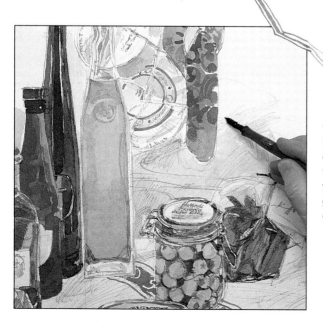

◄ **14** Very lightly hatch over the background wash with pen and ink to enliven the shadows. Vary the colour of these strokes – use nut brown, canary yellow and a mix of blue and emerald green in the background, and blue across the dishcloth in the foreground.

Tip

Bottle arrangement
It's a good idea to arrange your ink bottles in a logical

order so that you can find each colour immediately. The artist separated the cool colours from the warm ones, and placed them in two rows with the lightest first and the darkest last. The two browns and the two bright colours – carmine and crimson – were separated from the others.

▶ **15** The depth of colour of the liquid in the bottles has been rendered well, but you also want to give an impression of the shiny, reflective surface of the glass. To do this, take back some paint with a craft knife to provide a few highlights here and there.

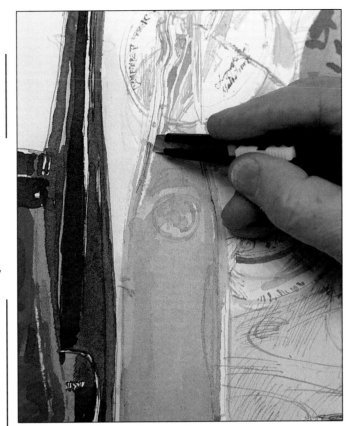

▼ **16** The final picture is a bold and lively interpretation of Mediterranean speciality food. Although at first it's the colour of the bottles at the centre of the composition that holds the attention, on closer inspection some of the most beautiful parts of the picture are to be found in the drawing around the edges.

Note, in particular, the cheese box reflected through the glass of the tall bottle and the lively effect of the multi-coloured pasta shells.

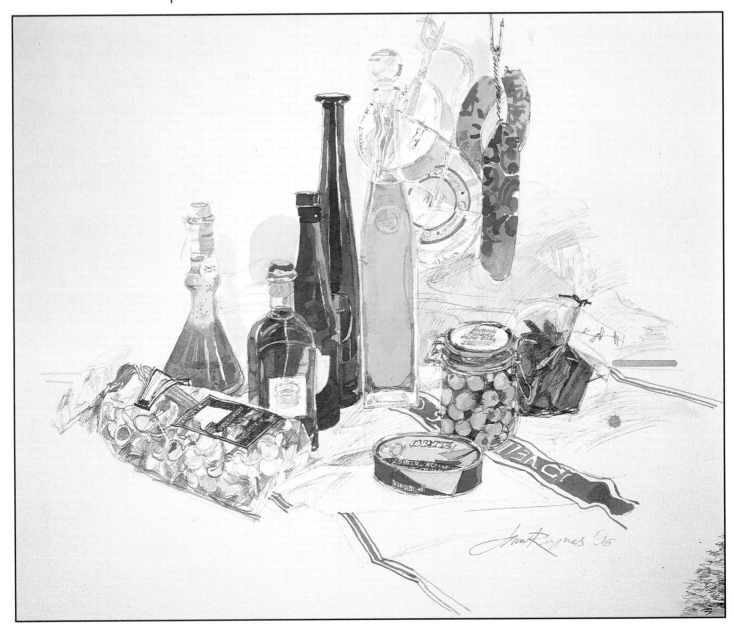

Brush pens

Brush pens, as their name implies, are a cross between a pen and a brush. The flexible fibre tip is shaped like a paintbrush so you can create a variety of marks that look very similar to brushstrokes.

Brush pens come with two different types of ink. Some use water-based ink which is soluble, so you can blend the colours on the paper with a paintbrush and water, creating washes or graded tones of the same hue.

Spirit-based brush pens, on the other hand, leave permanent marks. You use them on special bleed-proof papers which hold the ink and retain crisp edges. On smooth drawing and other non-coated papers, the ink soaks in to leave a blurred, rather soft edge. This effect can be attractive, especially if combined with pencil, pastel and crayon.

Most ranges of brush pens are available in a choice of colours, from as few as 12 to the more professional ones which have 100 to 144 colours. When you are buying brush pens for the first time, start with a limited choice, as with paints, and build up from there.

Using brush pens

By varying the pressure you put on the brush pen, and the angle at which you hold it, it's possible to produce a variety of marks, from fine, medium, to bold strokes. With practice you can be remarkably consistent in line width and also create flowing lines of varying widths. This makes brush pens wonderful for line drawings. Some ranges have a fine-point fibre tip at one end and a brush at the other, so that you have the advantages of both kinds of mark.

You can combine brush pens with other media for some stunning effects, and you don't have to keep dipping them like a paintbrush, so your drawings remain fresh and lively.

fine point

brush tip

◄ The double-ended brush pen is ideal for sketching and line drawing. The fine-point fibre tip is fed with ink from the same reservoir as the brush tip, so you get a perfect colour match.

◄ The tip of a brush pen is almost as bendy as a paintbrush, and is resilient enough to spring back into shape after each stroke.

▼ The main difference between the many ranges of brush pens available is in the fibre tips — they vary in length, shape and rigidity. It's a good idea to buy one from each range you can find, then experiment to see which you prefer.

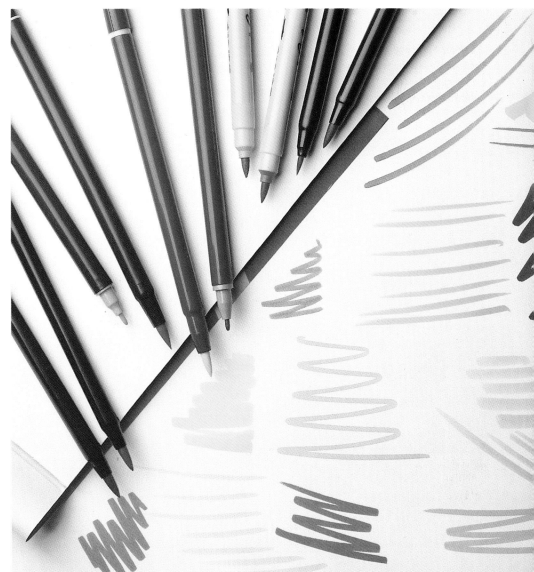

YOU WILL NEED

- *15 x20in (38 x 51cm) watercolour paper*
- *Nine brush pens: emerald green, olive green, moss green, dark brown, yellow ochre, grey, dark green, orange and greenish-yellow*
- *A No.2 soft brush*
- *An H pencil*

Brush pen marks

1. Hold the brush pen upright and use the tip to make thin, spiky marks for the twigs.

2. Hold the brush pen at a 45° angle and, using the tip, make sweeping strokes that taper off for the branches and foliage.

3. Flood clean water into the ends of the strokes to blend the grass blades into the surrounds.

4. Hold the pen on its side and drag it across the paper grain for the middleground grass.

5. Make a stroke with one edge of the brush on dry paper, the other on wet for the front grass.

Grazing sheep

The artist spent many hours sketching sheep in her sketchbook. She concentrated mainly on anatomical details – heads, legs, shape and position of the ears and so on – but also made a number of different sketches showing standing posture, the sheep asleep, feeding, grazing and lying down on the grass. These quick pencil sketches, as well as the more detailed studies, were then developed into a good composition for a picture using water-soluble brush pens.

▶ **1** Sketch your basic composition on to a sheet of watercolour paper with the H pencil. Draw around the lambs in the front using moss green and olive green pens.

▼ **2** Carefully blend the outside of the outlines around the lambs with the paintbrush and some water. This creates a 'halo' effect which makes the light-coloured animals – those right in the foreground – stand out in silhouette. The blended colour also helps to integrate them into the landscape where they are standing.

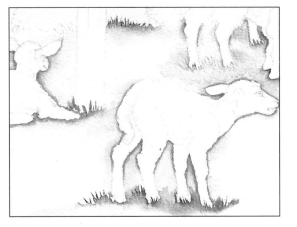

▲ **3** Work in some of the details of the landscape in the foreground. Use the brush pens freely, making quick, short sweeping strokes to indicate grass and undergrowth.

◀ **4** Use the brush and a little water to blend the tufts of grass into the surrounding area. Leave the tips of the blades of grass untouched so that they remain sharp and spiky.

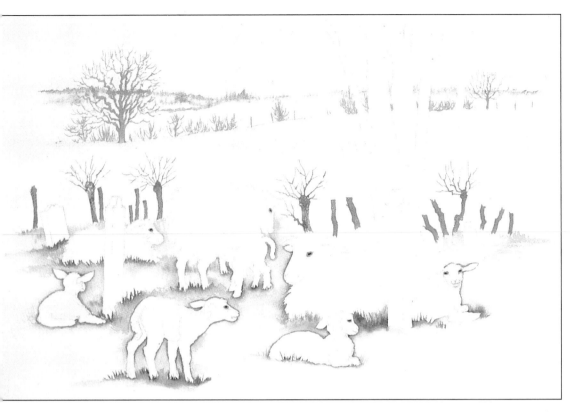

◀ **5** Draw in the contours of the landscape, the distant horizon and the lines of trees and hedgerows. Use grey for the far distant shapes to establish a sense of space, then change to yellow ochre for the middle distance, and brown for the near row of trees.

Blend the green grass around the animals with water and a clean brush.

Use yellow ochre and brown to touch in the dark eyes of the sheep.

▶ **6** With the greenish-yellow, block in the middleground grass by drawing the brush pen lightly across the surface of the rough watercolour paper, at the same time allowing some of it to show through for a granular effect.

▼ **7** Continue with this technique until you have filled in all the middle distance. Don't take the colour up to the edge of the paper: instead allow each area of colour to fade gently away towards the edge for a vignetted effect. Using dark brown, fill in the back of the trunk of the main tree.

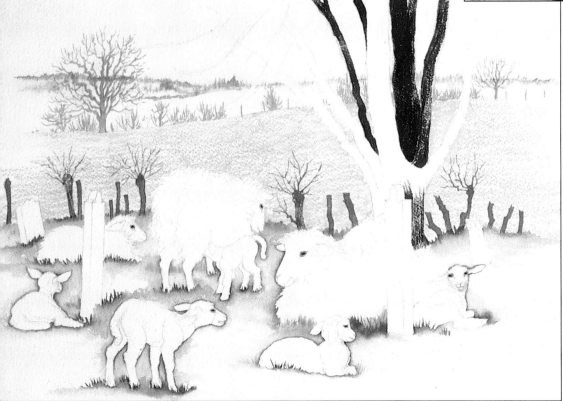

Tip

Brush with the outdoors

Brush pens are excellent for sketching outdoors. All you need are a few water-based pens, a bottle of water, a brush and a black drawing pen, and you have a lightweight outdoor sketching kit. The ink dries at once, and you don't have to bother about mixing paints or inks.

► **8** With the dark brown and emerald green pens add the main branches to the tree using strong, feathery strokes which tail off at the ends with a flick of the wrist. Build up the branches with a touch more emerald green to create a convincing mass of dark foliage. Use your brush and water to blend some areas of greenery and mould the rounded shapes of the tree trunks. Take care not to obliterate all the white spaces, or your tree will merge into a solid area of colour.

◄ **9** Check the yellow ochre of the tree in the middle distance. If it conflicts with the general tones in the middle and far distance, lighten the tone by blending the colour with brush and water. Add grey to the stones and yellow ochre to the sheep fleeces.

Note that much less detail is visible – all that is needed here is a general impression to convey the idea of distance.

▼ **10** Touch in a little orange and greenish-yellow to suggest lichen growing on the stones. Use greenish-yellow to define and sharpen the shape of the sheep bodies under their fleeces.

At this stage, the artist felt that the final picture still looked a little top-heavy, so she introduced some bright emerald green into the foreground grass, dispersing it with washes of clean water.

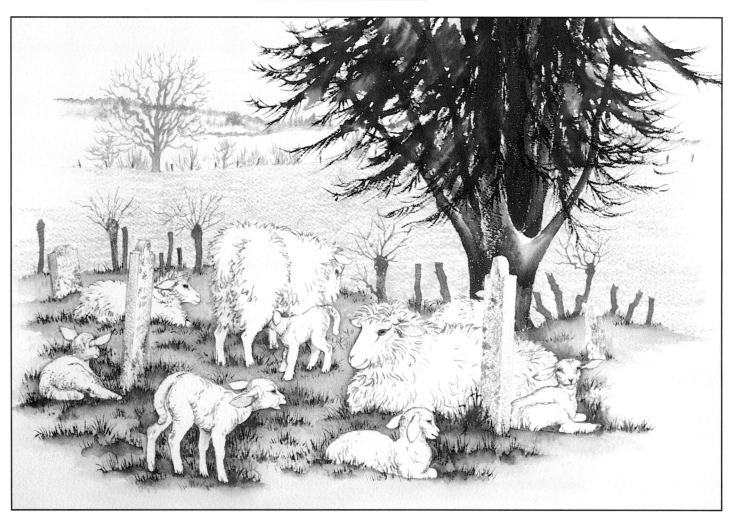

Marker pens

When they were first introduced, marker pens were used almost exclusively by illustrators and graphic designers, but now they are regarded as an interesting medium for other artists.

Marker pens are made by several manufacturers and each one produces its own range of colours. One leading firm, for instance, markets hundreds of colours, of which many are grey (see 'The important greys' overleaf). There are so many colours because markers aren't blended – you need to choose the right one for the job.

Regular markers have a chisel-tipped nib at one end. They are versatile, creating many different widths of line. Many types are available. **Double-tipped markers** are among the most common. They have a chisel tip at one end and a fine, pointed nib at the other. Both are exactly the same colour, fed from one reservoir of ink. **Triple-tipped markers** have three tips (chisel, pointed and ultra-fine). They can also be used as an airbrush by connecting them by hose to a can of propellant. **Refill bottles of ink** are available for some makes of marker.

Using markers

Like watercolour, you can build up marker colour from light to dark. For example, if you want to create shading on a blue vase, start by putting down a coat of blue, then build up successive layers of the same blue to get increasingly darker tones. An alternative method is to choose three blues – a light, a medium and a dark – and use a single application of each one.

For small areas of flat colour, lay overlapping strokes of the marker. For larger areas, use a brush and a bottle of refill ink. (Special 'transorbs' can also be used. They look like a large version of the inside of a cigarette filter, and are held by a bulldog clip and dipped into the bottle.) **Blenders** create a graded or blended effect, which is otherwise tricky to achieve. They look much like ordinary markers but contain solvent, which wets the applied colour again so that you can get rid of any hard edges.

SOLVE IT
Bleed-proof paper
Used on the top sheet of a pad of smooth drawing paper, marker ink has a tendency to bleed through to the next layer. The answer is to make use of bleed-proof paper. This comes in pads of various sizes and is specially coated on one side (the underneath) to stop the marker ink coming through.

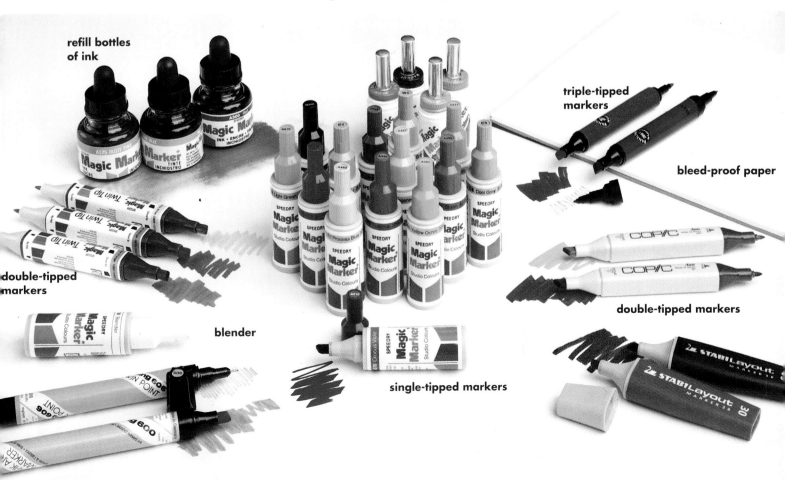

refill bottles of ink

triple-tipped markers

bleed-proof paper

double-tipped markers

double-tipped markers

blender

single-tipped markers

The important greys

As well as layering the same colour, or darker tones of the same colour, you can achieve shading by using various tones of grey (see the blue vase below). There are many greys available, generally in two ranges – warm and cool.

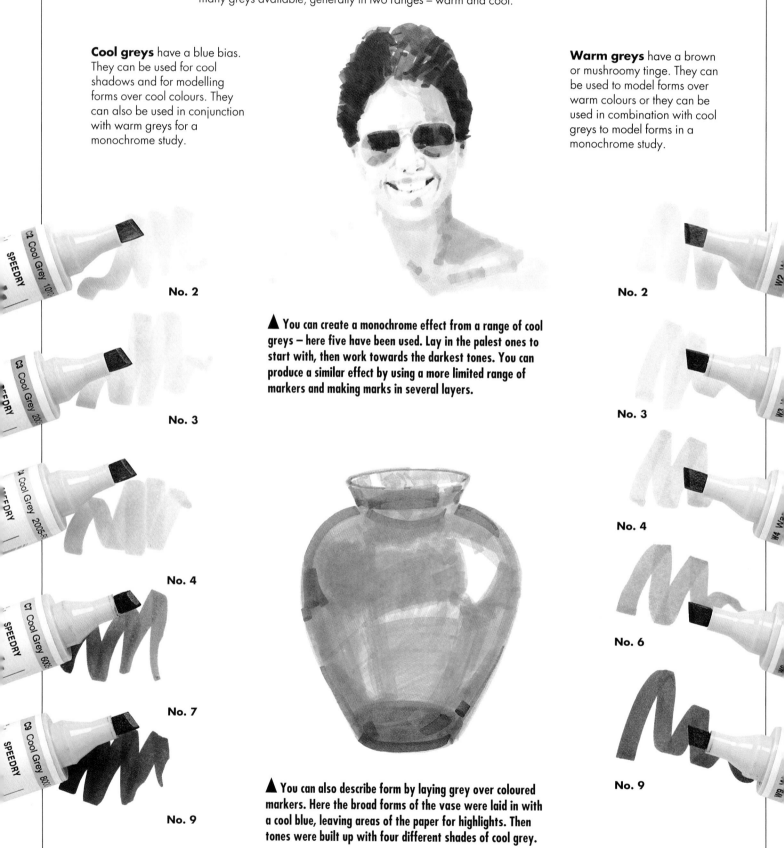

Cool greys have a blue bias. They can be used for cool shadows and for modelling forms over cool colours. They can also be used in conjunction with warm greys for a monochrome study.

Warm greys have a brown or mushroomy tinge. They can be used to model forms over warm colours or they can be used in combination with cool greys to model forms in a monochrome study.

No. 2

No. 3

No. 4

No. 7

No. 9

No. 2

No. 3

No. 4

No. 6

No. 9

▲ You can create a monochrome effect from a range of cool greys – here five have been used. Lay in the palest ones to start with, then work towards the darkest tones. You can produce a similar effect by using a more limited range of markers and making marks in several layers.

▲ You can also describe form by laying grey over coloured markers. Here the broad forms of the vase were laid in with a cool blue, leaving areas of the paper for highlights. Then tones were built up with four different shades of cool grey.

The Morgan Plus Eight

Markers are fairly unforgiving as far as mistakes are concerned, so before you carry out the steps below, think about what you're going to do and be decisive.

If you're working on a tight budget, bear in mind that you can make do without some of the markers. It's worth experimenting, for instance, with making a darker grey from layers of a pale cool grey.

It's difficult to make corrections with a fine-line pen (as you're going to do to establish the lines of the car), so make a pencil drawing first and then trace over it with a fine-line pen.

▶ **The set-up** Not owning a Plus Eight himself, the artist had to work from a picture. As you can see, the car is red, but exercising a bit of artistic licence – he'd always dreamed of driving a blue one – he changed the colour.

Working for yourself, you could draw your favourite car or follow this demonstration.

YOU WILL NEED

- ☐ *2-3 sheets of 18 x 24in (46 x 61cm) bleed-proof marker paper*
- ☐ *An HB graphite stick*
- ☐ *Clips or masking tape*
- ☐ *A sheet of smooth drawing paper (optional)*
- ☐ *A black fine-line pen*
- ☐ *13 Magic Markers: cool greys Nos. 1, 3 and 7, brown, light process blue, Minoan grey, storm grey, dark process blue, warm grey, yellow ochre, light green, olive, black, blender (optional)*

▲**1** Working on to one of the sheets of marker paper, make a pencil drawing of the car with your HB graphite stick. You'll find it easier to put in all the fiddly details – the radiator grill and headlamps – if you draw the car large.

▶ **2** Secure this pencil drawing to your board or table top using clips or masking tape. Now slide another piece of marker paper directly on top and secure this in place too – you should be able to see the pencil drawing clearly through it. Trace the drawing as accurately as possible, using the black fine-line pen.

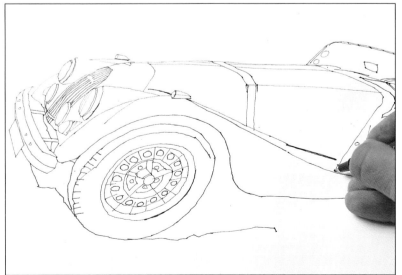

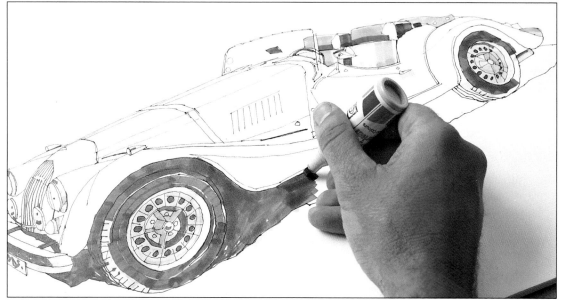

◄ 3 Remove the pencil drawing and replace it with a sheet of smooth drawing paper to give a more opaque surface to work on.

Half-close your eyes and look at your reference, simplifying its forms into lights and darks. Use cool grey No.1 to establish the lightest grey tones – on the backs of the car seats, for example. Remember to leave white paper highlights in places. Then, using cool grey No.3, strengthen some of the grey by going over it again. Block in the shadow under the car with cool grey No.7, also darkening tones here and there around the picture.

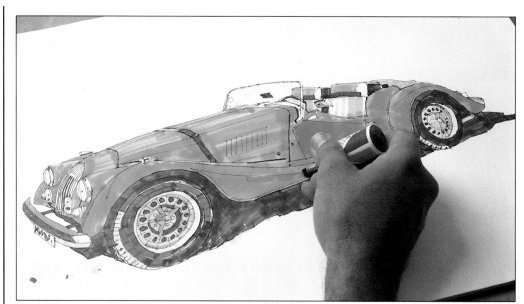

Tip

Test your colours
It's a good idea to have an extra sheet of bleed-proof marker paper next to where you're working. That way you can test your colours before you apply them (the tops of the markers give you an indication of the colour but not the shade). You could

also use it to make a few preliminary sketches of difficult parts of the subject, as the artist did here.

▲ 4 Establish the overall colour of the car with light process blue. You're aiming for a block of colour here with no hard edges, so you need to think ahead and work quickly, keeping the wet edge going. (A blender might come in handy.) Follow the form of the car with your strokes and remember to leave highlights where you need them. Mark the bottom of the front indicators with brown.

▼ 5 For the darker parts of the bodywork, go over the top of the light process blue with Minoan grey. Again keep the wet edge moving, but now you want crisp marks and hard edges to describe the car's form. Put in the rows of straight lines on the bonnet, using the same marker.

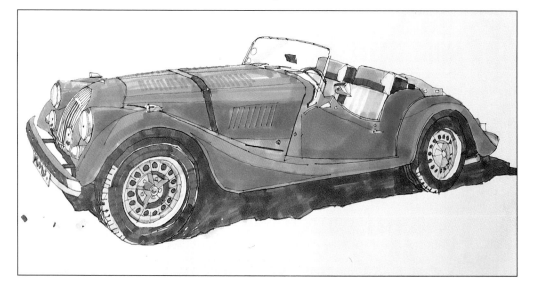

▲ 6 Concentrate on reflections on the bodywork, putting them in – as here over the headlights – with storm grey. In places, intensify the colour of the bodywork with dark process blue.

▶ 7 With cool grey No. 7 put some simple strokes on the tyres to suggest the treads – on top of the previous greys they will look almost black.

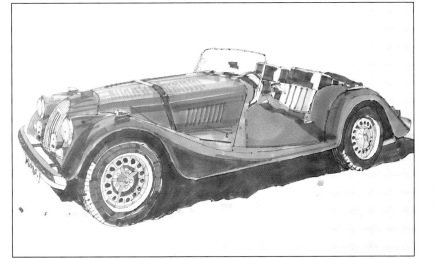

◀ 8 Now stand back from your drawing and check whether the tones are correct. Adjust them as necessary.

▼ 9 Draw a line of warm grey in the middleground, then work over some of it with yellow ochre. Use the yellow ochre again to put some touches of colour on the front indicators. Using light green, lightly put in trees and foliage in the middleground and background with an energetic scribble.

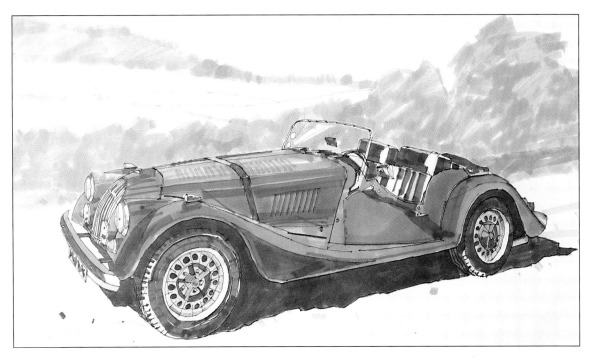

10 Using bold strokes, work some olive over the light green in the middleground for darker patches of foliage. Dot in some trees with the same marker. Use light green in several layers for some more trees in the background, then do the same with cool grey No.3 – this looks quite good dotted here and there on its own. Make a long loose scribble with Minoan grey for the sky.

11 For the background seen through the windscreen, a few bold strokes with light green, then olive, work well.

12 Finally go over the whole picture with a black marker, putting in the very darkest tones – on the backs of the seats, for instance. You may even decide that the shadow under the car needs adding. This black should bring an extra sparkle to the finished picture.

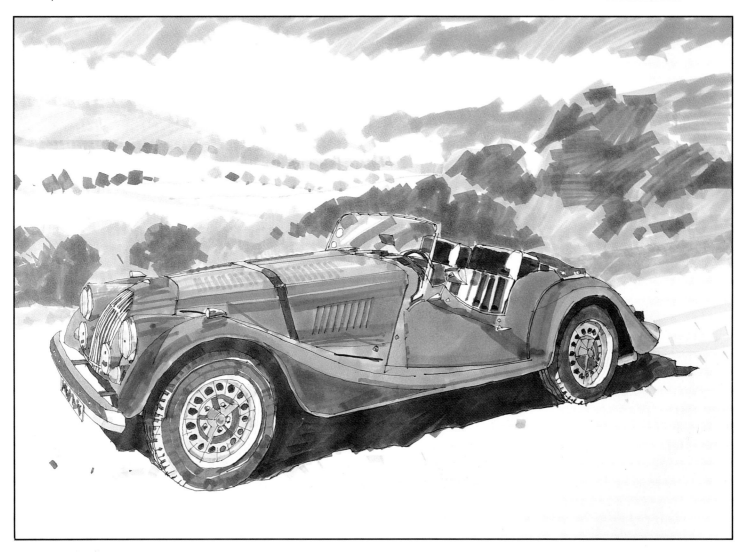

CHAPTER TWO

Exploring techniques

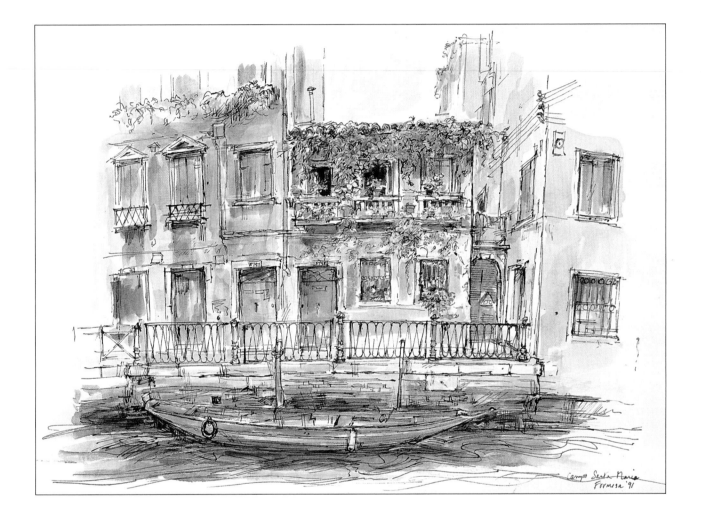

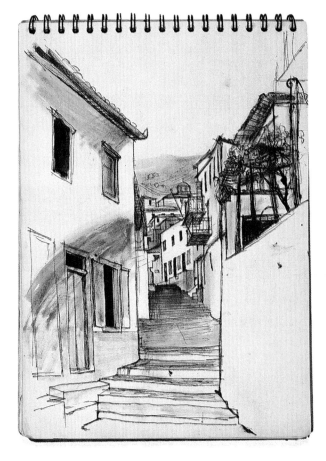

Rendering form through line

You can use pen and ink to create the illusion of form through a single expressive line that suggests the fall of light.

There are two fundamental ways of rendering the shape and form of a subject: through line or tone. Pen and ink is a linear medium and so line is the obvious starting place.

A dip pen fitted with a pointed drawing nib will produce a wonderfully varied line which responds to pressure. Indian ink dries to give a dense, shiny, black line of an even tone. However, by varying the pressure on the nib you can change the thickness of the line, making anything from a fine, incisive mark to a rich,

> **66** *Ink is almost irremovable but it needn't be as daunting as you think.* **99**

A few practical hints

● Match the nib to the scale on which you are working. Choose a medium nib, rather than a very fine one.
● Plan your composition carefully before putting ink to paper – there are methods of correcting an ink drawing, but it's best not to rely on them.
● Work flat so that the ink doesn't run.
● Put the ink where it won't get knocked over and keep it on the same side as your drawing hand – so you don't have to carry a full pen across the drawing, and so risk it dripping on the paper.

thick one. Lines can be smooth and flowing, or broken and stuttering.

These effects can be used to express the nature of the outlines of your subject, and to suggest the fall of light and shade. Start with a fairly simple subject (such as the plant on the next page) and use a simple fluid line to describe the edges and lines that you can see. Where edges need to be darkened or emphasized, increase the pressure to strengthen the line.

▼ **Whether you work boldly with thick dense lines, or, as the artist has done here, loosely but precisely using very light lines, you can create drawings with an unmistakable character.**
'Untitled' by John Ward, pen and ink, 19 x 13in (48 x 32cm)

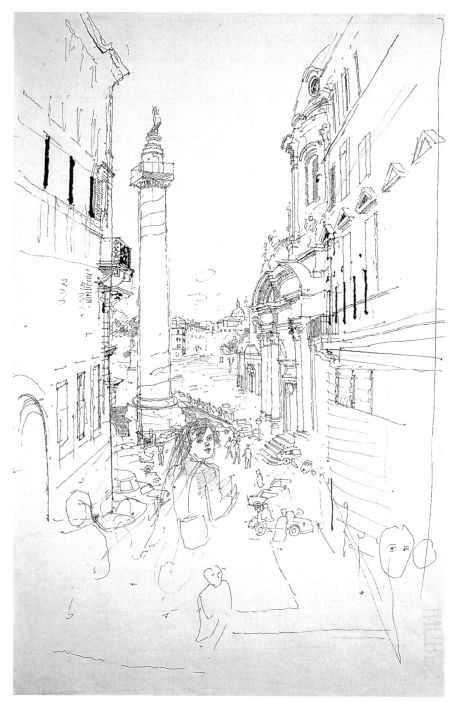

Peace plant

YOU WILL NEED

- ☐ A sheet of 12 x 18in (30 x 46cm) smooth drawing paper
- ☐ An H pencil
- ☐ A bottle of black waterproof Indian ink
- ☐ A dip pen with a medium nib

► This plant is a good choice as the leaves are broad but elegant and there aren't too many of them. The detail on the leaves is not exhaustive – but there's enough texture to make them interesting. The slender stems introduce new forms and the flowerhead, with its knobbly textured spike and curved hood, provides an admirable focal point.

▲ **The set-up** Distance yourself so that you can take in the whole of the plant at a glance, but are still close enough to appreciate textures. Turn the plant around until an interesting aspect faces you – a large leaf, for example.

Because leaves are essentially curled, flat surfaces, they don't look strong in profile. Elevate the viewpoint slightly to show off their shape. This helps to capture the spirit of the plant much better. You can see this in the quick drawing (right).

1 Lightly sketch in the shape of the plant and pot with an H pencil. Keep it simple – just indicating the various planes of the leaves and their positions, the angles of the stems and the masses of the plant and pot in relation to one another.

The underdrawing serves as a guide for the ink drawing. Don't press too hard or you'll bruise the paper – leaving channels for the ink to run into – and you'll make the drawing hard to erase later.

◄ **2** Hold the pen close to the nib to give a controlled, even line and start to draw the 'skeleton' of the plant. Don't merely trace over the pencil sketch – let it guide you, but keep observing the plant, freshening the sketch as you progress. Look at the supporting rib that runs up the centre of each leaf. Try to capture its curve and direction. Once you've got that right it is easier to put in the leaf's outline.

As you complete more of the drawing, you might want to rest the hand that is not drawing on a piece of kitchen towel – so that you don't smudge the ink.

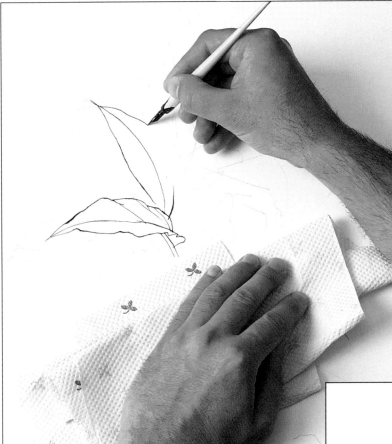

► **3** See how surfaces curve and edges are hidden. Look at the leaf on the left here. Note how the flow of the outline on the far side is interrupted because of folds. You can see the same wavy folds in profile on the leaves on the right and these rhythms repeat throughout the plant.

Get a feel for the qualities of the ink lines. Don't worry about the odd blot appearing. These often add to the effect.

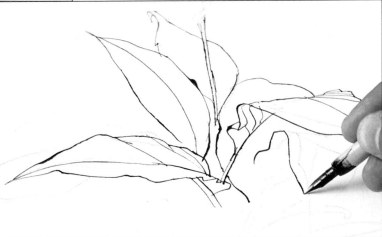

▼ 4 Keep the whole drawing on the go – just as you would a painting. Avoid putting in all the outlines and then filling in detail.

Holding the pen farther back from the nib, put in some of the ribs in the leaves. Let the weight of the pen do the work. This gives a much freer, more fluid line which trails away as you lift the pen.

Where a leaf is seen end on, don't ignore the folds but do as the artist has done here. Where the surface dips away behind one of the veins – on the left – make the line more emphatic. Then bring the veins closer together to comply with the rules of perspective.

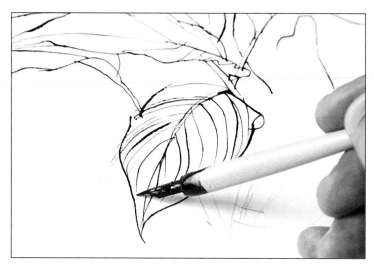

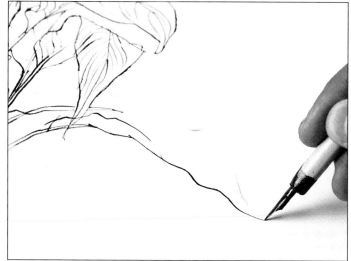

▲ 5 Never lose sight of the wonderful versatility of your pen and all the qualities of line at your disposal. You can't vary the tone but you can change the emphasis by pressing harder to make thicker lines and by turning the nib sideways to get fine ones. Here, a beautifully fluid line of varying thickness captures the whole outline of one side of a leaf.

◄ 6 If a leaf points towards you in reality, it must look as though it is coming towards you in your drawing. Where one leaf partially obscures another, it must look as though it is on top. Create this illusion by thickening edges. You can pull a line away from detail that lies underneath by simply making the line stronger. (You can see this technique in the nearest leaf here.) Where the leaf comes out into the open again, resort to a gentler line.

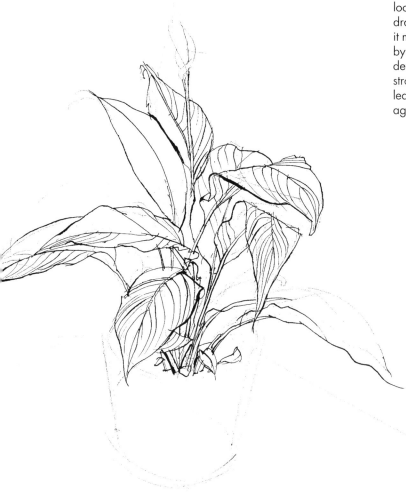

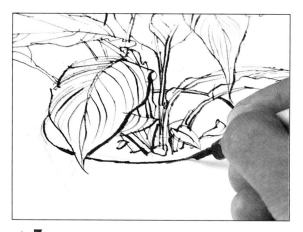

▲ 7 Try to get the ellipses at the top and bottom of the plant pot absolutely right. People instinctively know when they look wrong and misshapen ellipses create a sense of unease – which you don't want.

Because of perspective, the ellipse at the base of the pot should be closer to a circle than the top one. Letting your sketch guide you, draw in the top ellipse with a series of short pen marks. This allows more scope to correct the curve. Then complete the rest of the pot.

Tip

Precise ellipses

It's essential to get geometrical shapes, such as ellipses, just right. When doing the pencil underdrawing of the plant pot, you'll find it easier to draw full ellipses at the top and bottom — even though you can't actually see the far side of the pot. This way you can keep a smooth, continuous drawing rhythm going and produce a better shape. When you do the ink drawing, you can put in the nearside with a stuttering line, leaving out the far side.

▶ **8** Leave the flower – the focal point – until last. It's like the final piece in a jigsaw, and can be given its full value only when assessed against the rest of the drawing.

Draw the hood first, keeping the same rhythms going. In fact the texture on the flower spike consists of very small pimples, spaced at regular intervals around a central core.

Two spiral lines running in opposite directions describe the form of the spike. A few dots of ink suggest texture.

▶ **9** To make the pot look as though it's resting on a surface and not just hanging in mid-air, indicate the edges of the table. You don't want to end up with what looks like a technical drawing, so soften the line, letting the nib spring back at the end of the line, causing the ink to spatter.

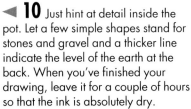

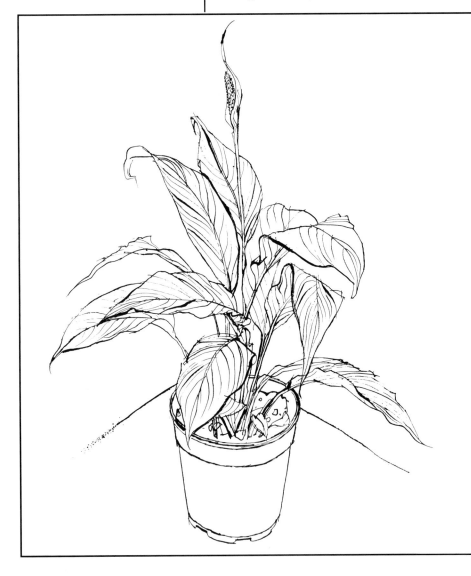

◀ **10** Just hint at detail inside the pot. Let a few simple shapes stand for stones and gravel and a thicker line indicate the level of the earth at the back. When you've finished your drawing, leave it for a couple of hours so that the ink is absolutely dry.

Here, the energy of the plant has been captured in its 'starburst' shape. The appeal of drawing is due largely to the great variety of line and although it stands in its own right, it would serve as a good basis for a pen-and-coloured wash drawing.

Textural marks

Hatched linear marks, dots, and broken lines can be used to express the texture and fall of light on the subject, but often what you don't draw can be as descriptive as the marks themselves.

When we look at a subject, it is interesting to attempt to interpret something of its character in a way that also reflects our own personality. Pen and ink offers a marvellous range of marks that can be used to do this, to convey both the texture and the shape of the subject. Take something simple, such as a chair or table. Some of the considerations are the proportions, the overall shape, the nature of the edges, the reflections, and the texture and the wood grain.

When you start a drawing, it is important to make sure that you check the measurements. You can map out the basic shapes with pencil, but try to build in confidence and to start plotting the shape directly with dots of ink.

The edges that are in strong light do not have to be fully described – try leaving them almost untouched, with just a few marks to suggest their presence. A series of 'hatched' lines can be used to describe textures and tones. It is important to plan their direction, nature and density carefully to achieve the effect that you require.

When you draw with pen and ink, it's essential to warm up first – both your hand and the nib you are using. Prop up your board at a slight angle, rest your arm on it and hold your pen loosely about half way up – the looser and more relaxed, the better. Looking at your subject, let your pen follow the movement of your eyes and feel the shape and proportions a few times. Test the marks that the nib can make. Make sure that you shake off the excess ink from the nib each time you dip it into the pot to avoid blobs. With pen and ink, you draw what is dark, not light, so look carefully at the shadows before you start – and remember, with ink you can't erase anything.

To start with, the only ink you need is one bottle of transparent waterproof black ink that dries to a shiny finish. The size of your drawing depends on the size of your nib – with a fine nib, you automatically draw on a small scale.

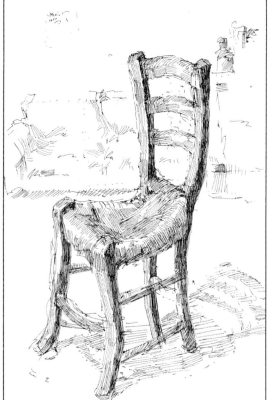

◀ These pen-and-ink drawings are slightly more elaborate than the drawings shown in the demonstration, but they use much the same system of lines and dots. Sensitive handling, with many individual pen strokes and careful build-up of tone, make these studies both charming and convincing.

Rush-seated chair

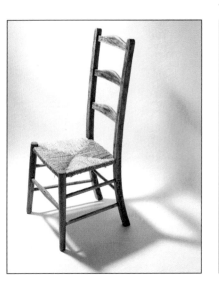

▲ **The set-up** Sit as close to the chair as possible so that you can see every detail – but not so close that your drawing board obscures it.

In this drawing, you are focusing on the shadows, highlights and textures, which are emphasized by strong lighting from above.

▲**1** Using the pen and ink, make tiny dots to map out the chair's shape and size, putting in small lines to suggest corners and the directions of the surfaces. Concentrate all the time on what you are looking at because it's difficult to correct ink, and a chair has very specific proportions. (If you like, you can sketch the picture first in pencil.)

▲**2** Holding the pen slightly higher up, dot around to sort out the widths of the bars and the angle of the seat. Hold your pen up in front of you as a guide, then half-close your eyes to check to see which direction the horizontal lines running – is the left side or the right side higher? Getting this correct at an early stage is important.

Tip

Handy tissues

Put the ink bottle on a thick wad of tissues so that you can shake off the excess ink from your pen to avoid drips.

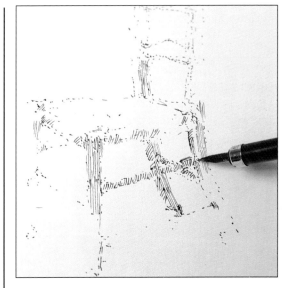

▲**3** Concentrate on the light and dark areas and begin to pick out the focal points – the strong dark areas. Start making more descriptive marks, such as little curves, to describe the rounded cross bars.

▶**4** You need to keep a check on the positioning, especially the exact position of the chair feet. Allow your eyes to dart backwards and forwards from point to point, making tiny marks to build up their positions.

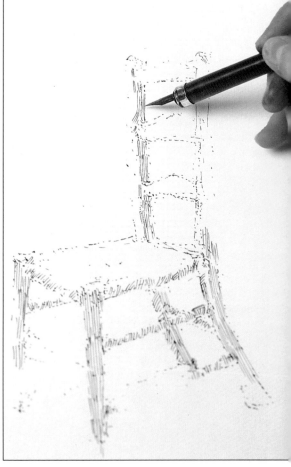

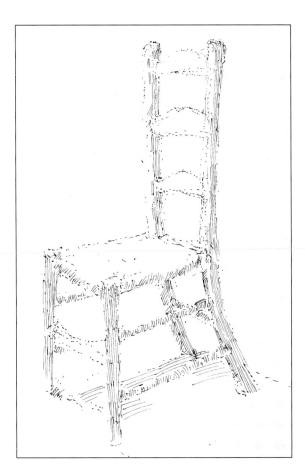

◀ **5** Now, with the clustering of the marks, the chair is clearly plotted out and you can begin to build up the shaded areas, making them denser. Start to put in the shadow on the ground under the chair.

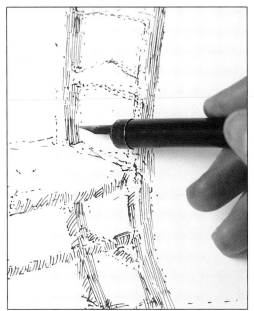

◀ **6** Stop, stand up, step back and look at your drawing to keep an eye on its overall development. Make sure that you are not overworking any one area.

Now pick out particular points to emphasize the darkest shadows, such as the inside, underneath the corners and the dark shadow under the chair which will make your drawing more three-dimensional.

▶ **7** Be confident and use more pressure to make stronger, darker marks. Tighten up the drawing with more detailed toning on the legs. Make very light, more descriptive marks to pick out the texture of the weave of the rush seat.

▼ **8** Now the chair is more solid. Loosen up again and let your pen work quickly, allowing movement to appear. Put in the shadow on the wall – but note that it is not as dark as the one underneath the chair.

▶ **9** Finally, keeping very loose and free, once more pick out the details – the light and dark areas – to let the magical character of the chair creep into the drawing.

The most difficult part is to decide when to stop – be careful not to overwork the drawing.

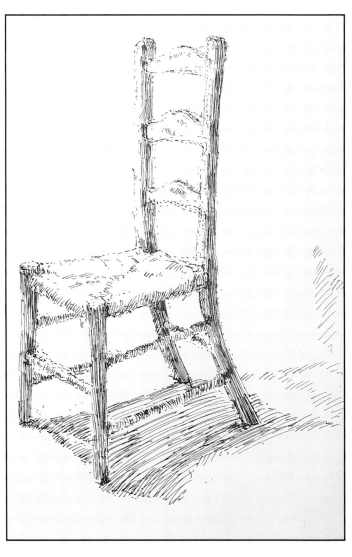

Little pine stool

► **The set-up** To see all the character of this little stool, it has been raised up to almost eye level, and lit from above to give dramatic contrast between light and shade.

◄**1** Starting in the centre, let the pen find its way around the shape of the stool. Use very light, wispy marks and dots to map out the stool's size, curves and angles.

►**2** All the weight should be on your wrist for balance so your pen can skate over the paper – following your eyes quickly and loosely. With free, expressive marks, tentatively work out the difficult edge of the side panels and the pointed arch between the legs.

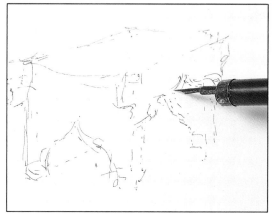

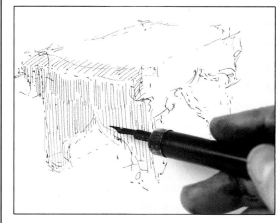

◄**3** Your eyes quickly get tired of looking at one point, so keep them darting around the subject, drawing at the same time and keeping your marks fresh and full of energy. Return to different areas and start to build up the shadows on the legs and side panels.

►**4** Move your arm so that it isn't over your drawing and so that your fragile pen nib doesn't bend or splatter with the pressure. Identify the various parts of the stool with lines in different directions, following the surface grain of the wood.

◄**5** Gradually build up the shadows on the underside of the stool. Add more pressure to tiny areas where the shadows are deepest. Putting in the shadow on the floor gives weight to the stool and helps it 'sit' on the floor.

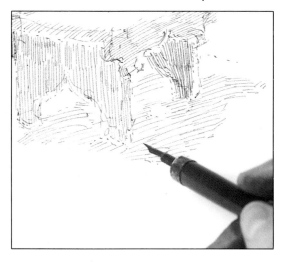

►**6** The success of your drawing depends on the delicate overlaying and clustering of expressive marks which gradually define the subject and bring it to life.

Developing lines

By exploring the different types of lines you can make with pen and ink, you can bring expression and character to your drawings. This works particularly well in portraiture.

One of the joys of drawing with a pen is the wonderful flow of ink through the nib – it means you can keep a continuous line going and call on dots, hatched, broken or continuous lines, thick and thin strokes, blobs, stipples and shading to give a huge variety of effects. And these help you render the subtle nuances of a person's features, expression, hair and skin with great sensitivity, and economy.

Remember, though, that pen and ink is very difficult to correct. The wonderful sense of fluency you achieve with pen and ink comes from the freshness and immediacy of its application, not from a laboured build-up of ink. Each line must ring true from the start. Underpinning your drawing with pencil can be dangerous because once

you have made a pencil drawing you often merely reiterate – rather than re-invent – the lines, which results in a flat, 'dead' picture rather than something fresh and lively.

If you want to keep a lovely fluency in your pen work, you must find a method to help you make measurements and establish the proper relationship between all the features on the face. A good way, chosen by the artist here, is to dot in the main features very lightly at the start, with no pencil work at all. The dots don't detract from the drawing, nor do they need covering up. Every mark put down brings its own quality to the work, and the dots (in very dilute ink) make a vital link from one position to another across the mask of the face.

▶ With any portrait, concentrate first on the relationships of the features. The width between the eyes is critical – if you don't establish this correctly, nothing else in the drawing will work (there should be roughly one eye's width between the eyes).

When you're satisfied with the positioning of the features, you can relax your pen and explore the marks available.
'Marcus' by Albany Wiseman, pen and ink on paper, 16 x 12in (41 x 30cm)

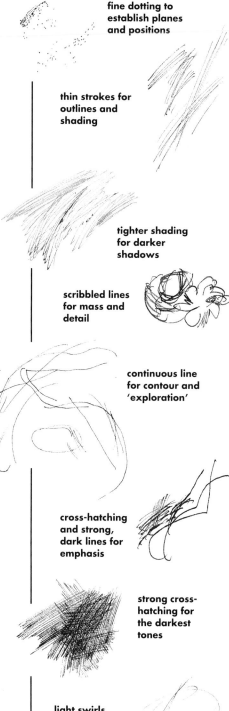

Making a mark
Practise different marks with your pen before you start the drawing. The artist diluted the ink with distilled water to help the ink flow smoothly and give a softer, greyer line for unobtrusive but helpful guidelines. The light grey lines can be strengthened later if needed.

fine dotting to establish planes and positions

thin strokes for outlines and shading

tighter shading for darker shadows

scribbled lines for mass and detail

continuous line for contour and 'exploration'

cross-hatching and strong, dark lines for emphasis

strong cross-hatching for the darkest tones

light swirls and dots for variety and interest

YOU WILL NEED

- ☐ A 22 x 15in (56 x 38cm) sheet of smooth drawing paper

- ☐ A fountain pen with a fairly large flexible nib (the artist preferred an old plunger type fountain pen so that he could alter the dilution of the ink, but choose a pen and nib that you are comfortable with)

- ☐ A drawing board; drawing pins or tape

- ☐ A bottle of black ink

- ☐ A bottle of distilled water

- ☐ Paper tissues

Naomi in a hat

▶ **The set-up** The hat framed the model's face attractively and gave some intriguing shadows. When working from life, take into account that the model sometimes has to move – try to make her as comfortable as possible.

▼ **1** Lightly dot in the eyes, eyebrows and the far cheekbone and the hat brim in dilute black ink. Work on the far eye and brow to establish the basic form. Using the dots, search for the exact relative positions of eyes, mouth, nose and cheek.

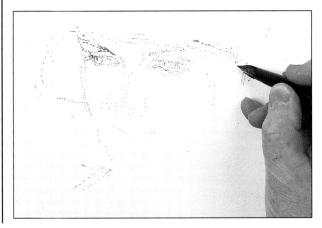

▼ **2** Draw the shape of the hat and the line of the neck and shoulder in light strokes, using the dots as guides. Dot in the nose and lips in darker ink. Return to the far eye and eyebrow, strengthening them so that you can read the eye sockets and the eyes travelling back into them.

▼ **3** Continue drawing the hat, shading a little on the far temple. Strengthen the eyes and eyebrows again, and begin the central flower motif on the hat brim. The remaining guideline dots bring a happy freshness to the picture – rather than impede, they help your eye read the lines. There's no need to remove them.

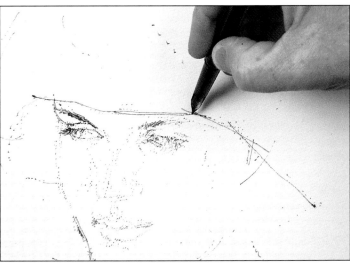

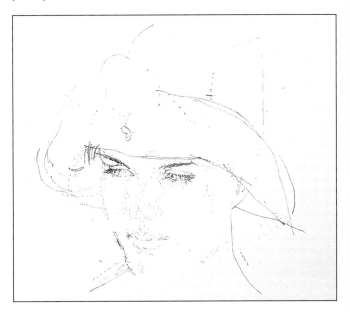

▶ **4** Now, use very dilute ink to draw light grey lines, starting with the flower on the hat and the hat itself, which is very floppy against the hardness of the cheekbones and the soft chin and nose. Drop in a line or two at the bottom of the nose and along the far cheekbone.

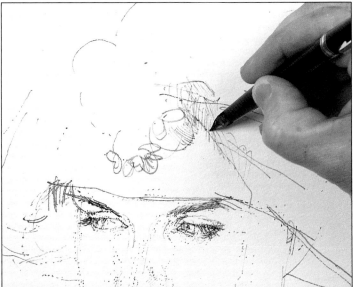

▶ **5** Reinforce the cheekbone, far eye, eyebrow and eyelashes. Note that the eyelid must travel around the spherical shape of the eye.

Work up the flower motif on the hat. The dilute ink is recessive while the pure ink lines now shaping the hat advance, creating a three-dimensional feel.

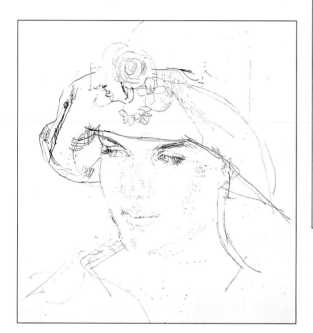

◀ **6** Strengthen the line between the lips, then sketch in the blouse. Put in the chin with a stronger line. (Note the artist was happy to correct the line of the neck.) Travel around from eyes to hat, back to the eyes and down to the mouth and chin.

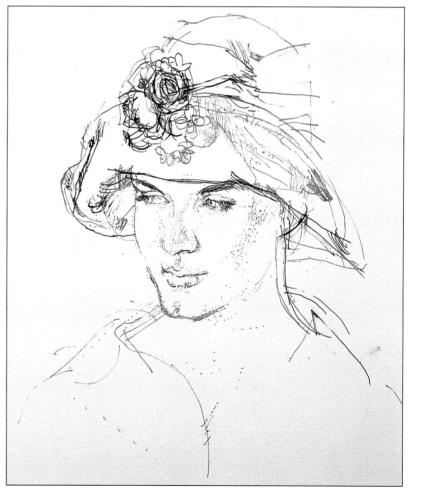

▲ **7** Return to the hat again and firmly establish its shape and contours. The darker ink lines contrast well with the pale grey dilute ink marks. With all the features in place, the artist now produced a livelier, freer line – breathing a real spirit of life into the drawing.

▶ **8** Establish the shoulders and neck relative to the face in free, loose lines. Put in some assertive points – ensure the line between the lips is correct, draw in the nostrils and strengthen the near cheek.

Work up the flower in the hat in stronger, darker lines (undiluted ink), making loose swirls and scribbles for mass and shape. Suggest the puckered band on the hat with a few angled lines.

9 Finish off final details around the neck and the side of the face. Using undiluted ink in the pen and more pressure, emphasize the lines indicating the right side of the neck and shoulder (the side nearest to you). These strong, dark, lively lines around neck, shoulder and hat emphasize the very careful, delicate treatment of the face itself. (If you treated the whole head like the face, it might not have so much vitality.)

10 With such economy of line, every stroke counts in this portrait, as do the lightness or darkness of the lines. Note the absence of heavy shading to indicate tones or shadows.

The artist has fully achieved a sense of three dimensions, at the same time suggesting the attractive character of the model. Positioning every feature in its correct place has produced an extremely good likeness, and he has retained a freshness, fluency and vitality in his use of pen and ink that gives great charm to the whole drawing.

Tip

Pen and ink tricks

Turn the pen wrong way up, with the nib down, so that you get a strong flow of ink and therefore a strong line. Dip the pen into some distilled water from time to time to improve the flow. When diluting ink, it's important to use distilled water – some inks contain shellac which, if mixed with ordinary tap water, causes the pigment to 'throw out', granulate and eventually become unusable.

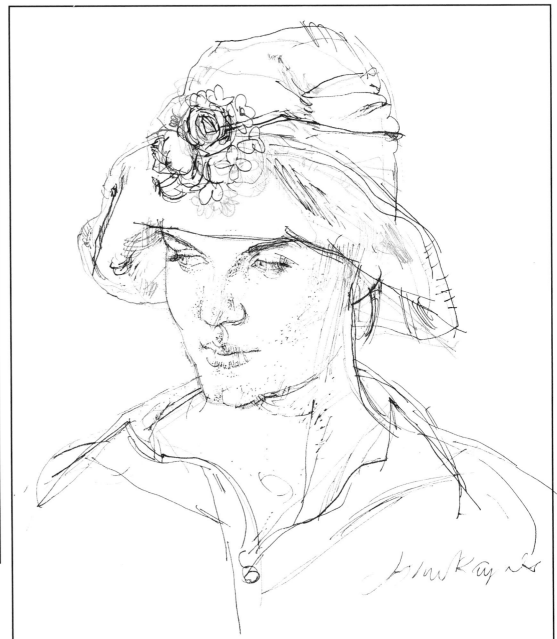

Softening line with wash

Pen-and-ink line can be softened by applying light brushstrokes of clear water, or ink, or watercolour.

A pen-and-ink drawing is really nothing more than a simple or elaborate arrangement of lines on paper. But the way that you draw the lines gives character, while changing the direction of the strokes, or altering the length and closeness of the marks, introduces depth, tone and form. A few loosely spaced horizontal lines mark out a flat surface; freely drawn, rounded, squiggly or cross-hatched lines suggest bulk or leafy vegetation; and a few simple bold verticals can convey the elegance of a building.

All of these free-style lines can be brought together to produce an exciting and lively drawing. And a little dilute black ink wash can emphasize areas of tone and form, and keep the drawing balanced, flexible and dynamic.

Any softening of a line made by waterproof Indian ink must be done before it dries. Fine-line (and related) pens vary in their reaction to water washes, so check them both while wet and when dry, before you start your drawing.

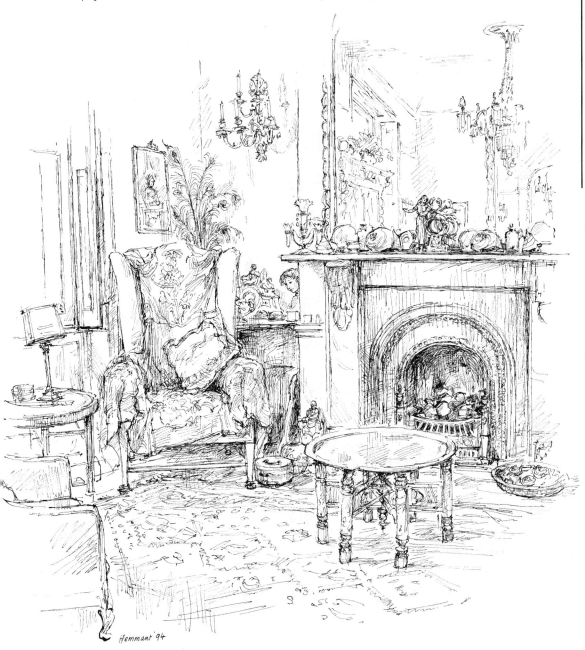

◀ **In this drawing of a room interior and the demonstration drawing overleaf, the artist has used loose, free-style scribbles and lines. A basic understanding of perspective is helpful for both pictures, but don't become too engaged in details since the liveliest and freshest of pen and ink interpretations should do exactly that — interpret what you see, not reproduce it!**
'Interior with Mirror' by Lynette Hemmant, pen and ink on paper, 15 x 22in (38 x 56cm)

YOU WILL NEED

- [] An 12 x 18in (30 x 46cm) sheet of smooth drawing paper
- [] A drawing board and gum strip
- [] A dip pen and a fine steel nib (choose a nib that you are comfortable with)
- [] A fine-line pen (optional – Artline Faxblac or Pilot Hi-Techpoint)
- [] A bottle of Indian ink
- [] Black watercolour paint; permanent zinc white gouache
- [] Two jars of clean water
- [] An HB pencil; soft pencil eraser
- [] Two round sable brushes: Nos.4 and 6
- [] A small mirror

The church of St. Giles

▶ **The set-up** This is the view from the artist's back garden – tailor-made for this drawing. It was a crisp March day and it rained on and off so she kept an umbrella to hand. She worked from a sitting position in line with her focal point – the church in the distance.

▼**1** For a subject as complex as this, it is a good idea to roughly map out what you want to include with your HB pencil. This gives a framework and, more importantly, shows whether or not your subject fits on the paper.

Draw in the line of the church roof, then repeat for the other main lines of the drawing: the horizon, the rest of the church, the garden walls, the edge of the patio and the outline of the small conservatory on the left.

▼**2** Now start to put in your composition with ink. Don't follow your pencil lines exactly – allow your pen to flow freely and expressively.

Once the main lines are drawn, begin to introduce small areas of wash for local tone. Dip your No.6 brush in a little water and brush it over the lines that you have made before they are completely dry. The ink flows gently into the water, which you can then pull across the paper to give very subtle washes. Be careful not to use too much water – you don't want to flood the drawing!

▼**3** Change to the dip pen (if you started with the fine-line pen) and continue drawing with ink. Work up some of the foreground features. This is fairly slow work so don't try to hurry things along. The fine-line pen gives a constant line, so switching between this and the dip pen gives you the versatility needed for the varying line work.

Again using a brush and water, pull out more wash inside the window recesses, underneath the foliage and on the patio surface, introducing local areas of tone. (The Indian ink gives a gentle brown-grey wash.)

◀ **4** Draw in the leafless trees in the middle ground with short, broken-line strokes. Note how the trees look spiky against the white of the sky, branching at their outermost points into fine, fan-like structures. The tiny changes in direction using this broken-line work bring the trees to life.

Try to work up the whole drawing to the same level. Don't concentrate too much on one aspect – you want to keep the picture in balance.

◀ **5** It's a good idea to stop at this point and check that all the elements are accurately placed and that the composition is working well. Viewing the drawing in a mirror helps you get an overall feeling about the whole picture (see Tip).

Use a soft eraser to remove any pencil marks and any other marks that you don't want to see in the final drawing. Some artists like to leave the pencil marks showing, but in this case the artist decided to keep the drawing clean.

◀ **6** View the drawing in the mirror again. The artist thought that the church spire was leaning too far to the right. With a No. 4 brush she painted over the inked lines of the spire with permanent zinc white gouache. (Ink isn't quite so permanent after all! But whiting-out mistakes like this must be done sparingly and only on small areas. The drawing soon looks flat, dull and lifeless if it's covered with corrections.)

Tip

Mirror, mirror
You can get a better idea of whether or not your drawing is working if you look at it in reverse. Hold a small mirror in front of the drawing and you will find you can pinpoint mistakes at once.

▶ **7** If you have used white gouache, allow it to dry completely before continuing. Then redraw the area carefully using the dip pen and broken-line work. Again, allow the ink to dry before going any further with the drawing.

▶ **8** Dip the No.4 brush in some water mixed with a little black watercolour paint, then wash over the tulips in the foreground and the bushes at the side. Continue the wash over the plant pots and under the garden chair to give some shadows. The black watercolour paint gives a much greyer wash than the dilute Indian ink, and can be used to greater effect, especially as you build up confidence.

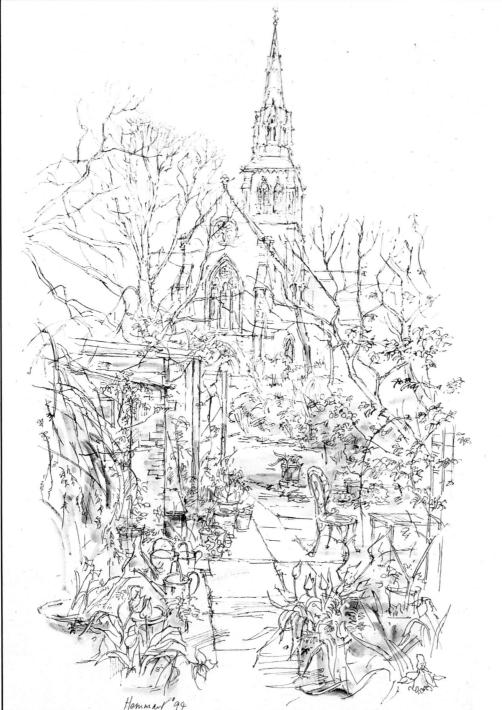

▲ **9** Continue to work up the elements of the foreground with a variety of different types of pen work – let your pen fly around the drawing. Some loose cross-hatching works well for the low bushes; denser squiggles drawn in fairly quickly give a sense of new spring leaves on the taller bushes to the right; and dramatic sweeping strokes indicate the tulip leaves.

◀ **10** Step back and take a final look at your drawing. The time to stop working on it is while it is still lively and full of energy. The final picture has no definite border and the edges are where the pen just happens to end its mark. This softens the image a little.

As your eye travels around the drawing, the vibrant pen work in the foreground gives way to the more regular lines of the church in the distance. The trees in the middle ground form a natural arch through which you view the church.

Variations on a line

It is interesting to use just one or two types of line and to build them up in a variety of linear and tonal effects, including hatched areas.

The appeal of pen-and-ink drawings generally lies in the character and variety of the linear marks that you can make with a pen nib. With an ordinary dip pen you can achieve shading, hatching, cross-hatching, continuous flowing lines, curves, circles, squiggles, dots, and blobs in almost limitless variety. But it is also perfectly possible to make an effective drawing by limiting yourself to just one or two types of line.

This is what the artist has done here. His drawing consists almost entirely of regular lines. For darker tones, he placed his lines closer together, laying them in wider apart for paler tones. You need some skill and quite a lot of patience to achieve convincing effects with this type of drawing, but the results are well worth all the trouble.

For the demonstration here, the artist has given some thought to lighting. He has tried to create strong contrasts of light and dark – this is essential in a black-and-white drawing because these tones help you to indicate form and stop the drawing becoming flat.

◄The set-up In terms of composition, these watering cans consist of three cylinders with ellipses at each end. Note how they are balanced against the verticals and horizontals. The whole set-up centres on a cross – the rake handle crossing the spout of the central can. Use this cross to help you work out positions and proportions.

The light shines from the right, casting shadows to the left. Use these tones to model the objects. The light hitting the cans emphasizes their roundness and brings them into the foreground, while the fork and spade, tucked behind in the shadows, give the picture depth.

◄1 Take the cross made by the spout of the centre watering can and the rake as a starting point and place it in the centre of your paper. It sets a balance and gives you clear angles to work from as you put in the other objects around it.

Move on to the centre can itself. Carefully draw the ellipse on its base. Ellipses can be tricky, so draw it very lightly to begin with; you can alter it later if necessary.

◄2 Draw in the top and bottom cans. Concentrate on making the angles of the base curves and spouts accurate. Draw the fork handle using the angles of the central cross to guide you. Let your pen travel loosely around the objects while you establish their proportions, especially the positions of the looped handles. It's important at this stage to keep the lines light while you arrange the shapes. Strengthen your marks only when you're happy with them.

Tip

Right first time
It's difficult to erase or correct pen and ink, so if you work without a pencil drawing first, it's important to take a long look at the set-up and become familiar with it before you begin your drawing.

▶ **3** When you have the outlines of all three cans in position, study the shadows and start to hatch them in with stronger, darker lines. Use directional strokes to describe the curved surfaces of the cans.

Start to put in darker marks that signify where the strongest shadows are – the small, dark shadow under the fork handle, for instance. These are important in the three-dimensional construction of your drawing and you need to keep adding to them as you go along to build up contrasting lights and darks.

4 Build up the shadow inside the mouth of the bottom can. This is one of the strongest shadows in the picture, but don't forget to leave white paper for the shiny rim. Work on the side and spout of the middle can, and on the left side of the bottom can. Indicate the slats of the lattice fence with hatched lines placed fairly close together.

▶ **5** The old pair of sheep shears are interesting, so make the most of them. Hatch in the flat pointed blades with straight lines and pick out the strong shadows on the rounded handles. Put in the shadow loosely.

It's important in a fine ink drawing to observe the tiny details – the quaint curled handle bracket on the can tells you that the can is made of metal, not plastic.

▶ **6** When you draw the fork and spade, take care to look hard at their familiar but very particular shapes and proportions. The rake has a subtle curve that complements the curved base of the watering can behind it. Make sure it looks old and worn by giving it uneven teeth.

Continue hatching the lattice fence behind the objects with horizontal lines to create a flat background that will throw the rest of the drawing forwards.

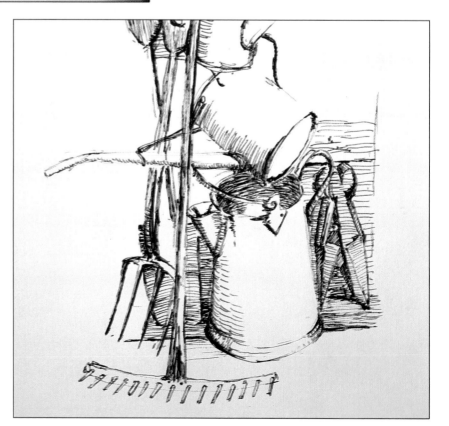

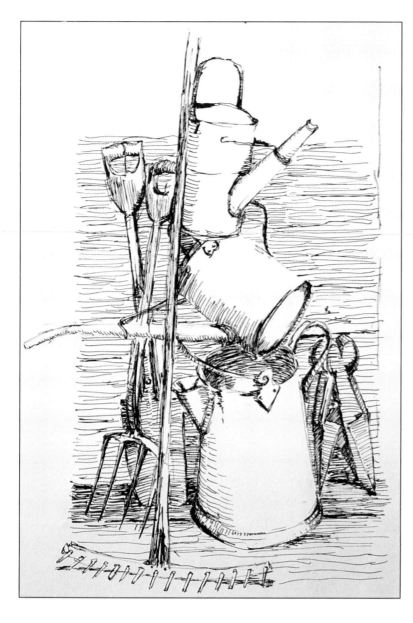

◄ **7** With the background in, work over all the objects, building up the ink marks for the darkest shadows. Think of the perspective as you draw the lines on the wooden floorboards and make the spaces between the lines wider as you come forwards.

Note how the rake has a subtle straight shadow flat on the ground directly beneath it.

YOU WILL NEED

☐ *A 13 x 16in (33 x 41cm) sheet of smooth, heavy drawing paper*

☐ *A drawing board and masking tape*

☐ *A dip pen and medium-fine nib*

☐ *Black waterproof Indian ink*

☐ *Tissues*

▶ **8** Keep returning to the darkest shadows, working over them again and again. To make them dense, you must almost block them in. Indicate the vertical post on the right, hatching in a series of short, horizontal lines. This neatens the right side and balances the composition.

◄ **9** Drawing with a dip pen is a slow process. You need to be very patient and become absorbed with tiny, accurate mark-making. Carefully put in the tiny shadows on the ground under each of the teeth on the rake. It's this kind of detail that gives authenticity to the drawing.

10 To finish the drawing, heighten the contrasts of light and dark to give the picture depth, particularly behind the objects. Look at the three basic sets of hatched lines on the left side of the can in the centre. They have different spacing and different lengths. This gives a very clear impression of the light shining on the big rounded surface, fading as it turns into shadow.

11 Drawing with pen and ink is very similar to engraving and etching. Everything is interpreted in terms of lines and shadows, while the white of the paper is left to indicate light. You can see this in the rounded forms of the watering cans, and also in the convincing sense of space created between the rake and the lattice fence.

You have to look hard when drawing in this way with pen and ink, especially if you work without an initial pencil drawing. To make a convincing drawing, you need to be methodical and work with a steady hand – one ink blot can ruin your drawing!

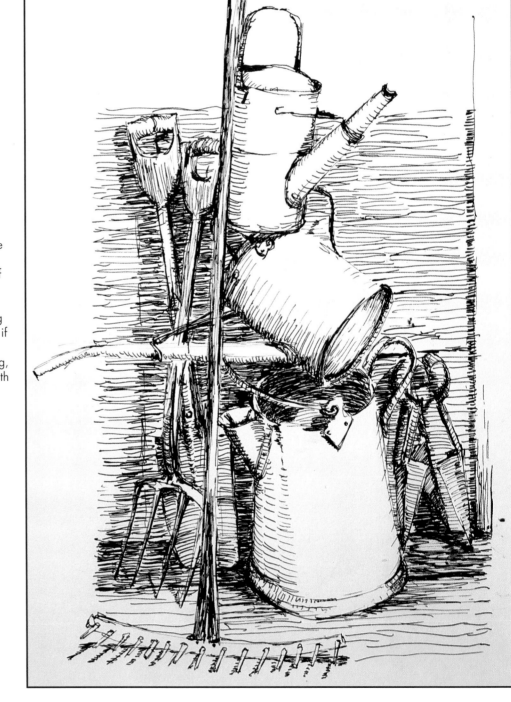

Contour lines

It isn't enough to use outline only in order to make a solid-looking line drawing of three-dimensional objects – you must use contour lines as well.

When we look at an object, we can see it in terms of the outline of the shape defined by its edges, which (more obviously if the shape is rounded) will be constantly shifting, depending on our viewpoint. We can also identify contour lines, which travel across the object and defining its profile. An awareness of this type of line will give an important key to making a convincing portrayal of mass and form. Look for surfaces with seams, joints, patterns or regular texture running over them – rope, footballs, suits of armour, patterned material, screw threads, shells, tortoises, cacti,

> ❝ *Part of the function of drawing in line is to be as economical as possible.* ❞

bamboo, tiled roofs, basket weave and tree bark are all likely candidates.

Explore the range of marks at your disposal: try undercharging the nib to give a stuttering line, or overcharging to create puddling effects. For good control, hold the pen close to the nib; for more freedom, hold it farther back. Don't worry about light and shadow, simply aim to reveal the form with contour lines. Above all, keep your drawing lively. The more fun it is, the more you'll enjoy drawing and the more you enjoy yourself, the better you'll draw!

▼ **Contour lines work hard here. The folds of the bedclothes – mostly in line – give the bulk of the form lying beneath. Hoops around the sleeves describe the cylindrical forms of the arms. Some contours run longitudinally – up the front of the nightdress and over the bulk of the pillow, for example. Whether you are a beginner or, like Rembrandt, a master draughtsman, you'll find contour lines a great aid to drawing clothed figures.**
'Saskia Asleep' by Rembrandt van Rijn, pen and wash on paper, 8 x 5¹/₂in (21 x 14cm)

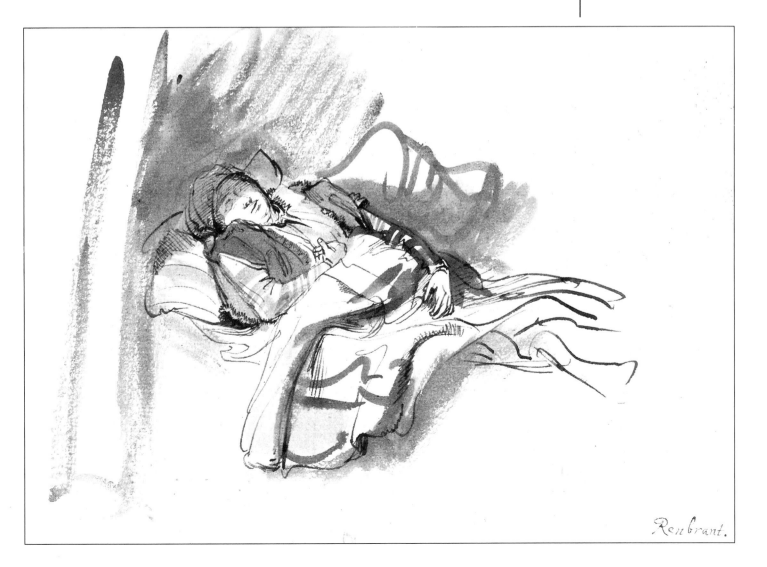

YOU WILL NEED

- ☐ A 12 x18in (30 x 46cm) sheet of good-quality smooth drawing paper
- ☐ An HB pencil
- ☐ A dip pen with a medium nib
- ☐ A bottle of Indian ink
- ☐ A firm eraser
- ☐ Piece of blotting paper or kitchen towel

Langoustines

◀▲**1** Crustaceans have segmented bodies which make clearly defined contours around the form. The stripes of the cloth give a perfect excuse for drawing the rise and fall of its creases and folds using line only. Unless you feel confident enough to dive straight in with pen and ink, start with a pencil drawing.

▶ **2** Draw precisely but loosely – gauge the angle of the shellfish' bodies, pincers and legs and the stripes on the cloth. Draw an ellipse for the plate and use the negative shapes to check for accuracy. And try to capture the character of your subject: the 'busy' quality of the shellfish, against the languid ellipse of the plate, for example.

Tip

Nib skills

Don't be afraid to use the side or back of the nib. Use the side for a very thin – incisive – mark, or flip it on to its back for a much broader mark. You can even vary the thickness as you draw by turning the pen.

◀ **3** Let your pencil drawing guide your pen but avoid tracing over it unquestioningly – aim to rediscover your subject. The shellfish are the focal point. Their carapaces look dramatic and crunchy. So charge the nib with plenty of ink, hold the pen loosely and then explore the contours around the segments with bold lines. (Note how the segments curve and fit into one another so the bodies curl – like croissants!)

◀ 4 You might find it tempting to add a bit of shading or hatching – don't. Follow the drawing through purely in line, travelling over and around forms, along edges and outlines, using any patterning or regular texture – such as nodules along the sides of the shell and pincers – to help you describe the forms.

▲ 5 On a flat surface – such as the cut faces of lemon – the contour lines are straight. Use this fact to make the lemon in your drawing rise up and fall away. A bit of stress under the front end reads as a shadow, making the form tuck under.

Beware – wet ink!
Make sure the ink is dry before rubbing out the pencil lines. Particularly

where puddles have formed, ink can take hours to dry. If you rub over ink that is only just damp, you stand a good chance of making a smear that could ruin your drawing.

▲ 6 Keep your whole drawing on the move. At this stage, it looks very busy – more so because you can see both ink and pencil. Many lines have been entirely repositioned, in particular those on the cloth.

◀ 7 If you laid the cloth flat, its stripes would be straight, and (ignoring colour) you could represent them with parallel lines. But here, the creases cause the lines to twist and dislocate. Drawing patiently and concentrating hard, record these changes in direction. Where lines dislocate, draw the edge of the crease as it cuts across the stripes.

► **8** While a technical pen gives a line of only one thickness, the beauty of a dip pen is that you can use it to make lines of various thicknesses (and all kinds of marks). Try turning your pen over and using the back of the nib to make thicker lines – as shown here.

▼ **9** Beware of pushing your drawing too far. There comes a point when, if you continue to draw, you risk ruining the effect. When you feel you've gone far enough, let the ink dry completely and erase the pencil. If you want to develop your drawing further, you might try introducing watercolour washes or coloured inks.

Cross-hatching in colour

By hatching and cross-hatching in a rapid, energetic manner with felt-tip pens, you can produce vigorous and brilliantly-coloured drawings.

Felt-tip pens are ideal for colourful, free-flowing linear sketches. But when it comes to putting in patches of tone, they can be a little more problematic. Blocking in flat areas of a single colour can look unsubtle. Blending two or more colours into each other is perfectly possible since felt-tip ink is transparent, but if overdone, the strong colours produce dull and dirty results.

The answer is to use hatching and cross-hatching to create shimmering broken-colour effects. You can hatch several colours, one on top of another. And, since the white of the paper is not completely covered up, a certain luminosity is retained. Furthermore, in this drawing, the use of hatching has been most successful in simulating the texture of the fields.

The artist used a coloured pencil sketch that he had drawn on location as a reference for his felt-tip study. Although the approach to both

drawings was very similar, the two media have produced very different pictures. The coloured-pencil sketch is perhaps a more faithful rendition – it has a muted charm, capturing the heat and stillness of the Italian countryside under the afternoon sun. The felt-tip work, on the other hand, is more of an imaginative recreation. It's bold and exciting, with the striking colours demanding the attention of the viewer. And the strong quality of felt tips is enhanced by the loose, expressive drawing technique that has been used.

1 Make an initial sketch with a light purple pen. This should involve little more than placing the major features – the trees, the buildings and the fields.

The set-up The artist used a coloured-pencil drawing from his sketchbook as a reference. If you don't have an appropriate sketch, try drawing a landscape on site. The beauty of felt tips is that they are portable and don't need to be mixed with water or anything else.

YOU WILL NEED

☐ *A 14 x 11in (35 x 28cm) sheet of smooth drawing paper*

☐ *Eleven felt tips: yellow, red, light blue, dark blue, light purple, light green, dark green, light brown, mid brown, grey and black*

☐ *Two Magic Markers: dark green and pale blue*

◄ **2** Work on the vegetation, first with light green, then dark green. Try to vary your drawing techniques as much as possible, for instance using hatched horizontal lines to fill in the foliage of the tree at the top and on the left, and curved and squiggly lines for the central trees.

▼ **3** Continue building up the colours, adding red, yellow and touches of mid-brown and light blue.

Enliven the drawing by hatching over horizontal lines with diagonal lines of a different colour. Also use some enlivening complementary colour – red – to help describe the foliage in one or two of the green trees. Note how the foreground well adds an interesting detail.

▼ **4** Fill in the shadow of the tree on the left in blue and red – blue darkens the shadow while red, as the complementary of the green of the foliage, invigorates it. Make sure, though, that you are sparing in your use of blocked-in areas of flat colour – they tend to deaden the vibrancy of the hatching.

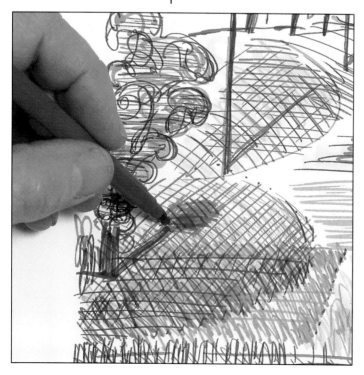

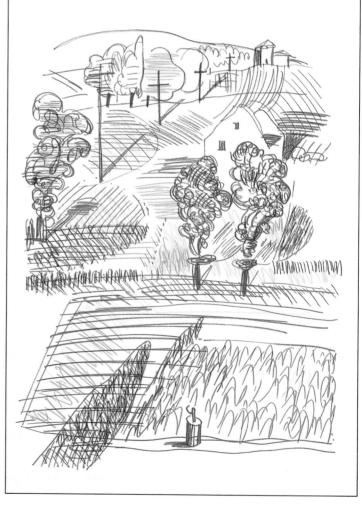

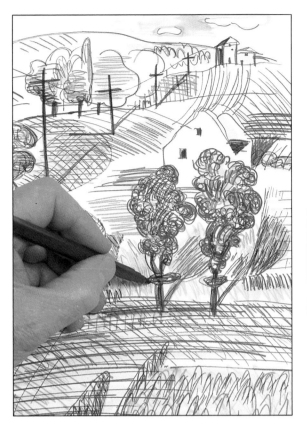

▶**5** Give an indication of the sky with the pale blue marker, overlaying for dark tones. Use the same colour on the two central trees. Build up the foliage and shadows of the trees in dark blue, using curling lines to contrast with the straight hatched lines on the adjacent fields.

▼**6** Add some light brown over the fields to create the impression of a sun-baked landscape. Use the side of the tip to create broader marks.

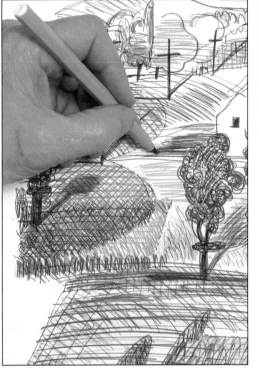

▼**7** Fill in the foliage of the left-hand tree with the thick end of the dark green Magic Marker. Note how this deepens – but does not obliterate – the underlying colours.

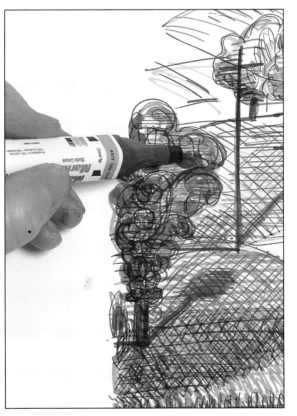

▼**8** Draw the dog in the foreground with black and grey – this gives your drawing a whimsical touch. Also put in the dog's shadow in brown to prevent it floating in white space.

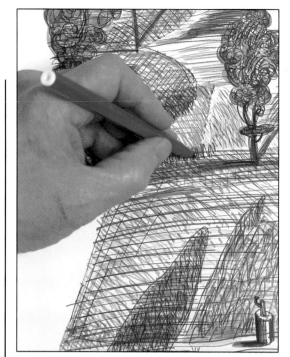

Tip

Bold and brash
The beauty of felt tips is that they are bright, bold and brash. So don't worry about matching your colours precisely with your reference or, if you are working on location, with the subject itself. Indeed, the use of arbitrary colour can add a great deal to the vibrancy of a felt-tip drawing.

◄ ▲ **9** Introduce some of the cooler, recessive tones in the landscape by hatching in light blue (left). Use this colour to break up the different areas of texture. As a final touch, put in a few plants on the path in the foreground so that the dog doesn't look completely isolated (above).

▶ **10** At first glance, the final picture can be seen simply as a two-dimensional design. But by vigorously hatching in different directions with different colours, the artist has created an exciting patchwork of colour and texture effects.

The image is also carefully constructed to give some impression of receding space. The shadows of the foreground and middle distance trees lead the eye into the picture, towards the roofless house. This house stands out because it has been left white. The eye is led farther up the picture to the buildings at the top right by the row of telegraph poles and the sweeping lines above the roofless house.

Negative drawing

Working on the spaces between objects in a composition is an interesting starting point, using a fine-line pen to build up an intricate network of hatched lines.

You might expect an artist in Venice to be inspired by the beauty of the architecture or the romance of the gondola-strewn canals – but not necessarily a washing line. Certainly, the artist returned from his Venice trip with dozens of photographs and sketches of traditional views, but what caught his eye was a quirky scene of shirts hanging in front of a dilapidated wall.

He had taken the photograph with hardly a moment's thought, but back in his studio he saw how well it worked as a composition. The white shirts stand out against the mid-tone of the wall, and their irregular shapes play off well against the horizontals and verticals of the windows behind. The wall itself, worn by water and weather, provides a wonderful variety of textures.

The choice of medium for this scene was two black fine-line drawing pens – one old and one new. The slightly scratchy older pen was used for the initial tentative stages and some of the paler tones, while the new pen – which gave a generous, inky line – was particularly useful for filling in the shadows. Using only black fine-line pens may seem rather restricting – but with care and patience, you can build up an intricate network of hatched strokes.

◀ The set-up The artist was tempted to use a coloured drawing medium to capture the beautiful earth colours of the wall, but he was worried that colour might detract from the graphic composition and the bold blacks and whites.

The two black fine-line pens created an interesting drawing which could also serve as a preliminary study for any future colour work.

▲1 Start by defining the clothes on the washing line with the old pen. Do this by using the 'negative' process of hatching in the surrounding cast shadows. Your strokes should be quite tight, but not too uniform – irregular hatching suggests that the shadows are moving.

◀2 Now turn to the new pen to begin on the deep shadows in the window. Here, the hatching strokes should be slightly more uniform. Use a ruler to prevent straying beyond the window's outline.

▶ **3** Continue with the new pen to sharpen and deepen the shadows of the shirts. You could have used the new pen initially on these shadows, but the first marks – especially when you don't have a pencil sketch to follow – are always a little tentative. This method allows you to pick up momentum as you gain confidence.

◀ **4** Return to the old pen to put in some of the lighter tones in the windows. Note how the outlines of these areas have been emphasized by pressing the pen harder at the beginning and the end of each hatching stroke.

Also use the old pen to put in some of the lighter shadows in the folds of the shirts.

YOU WILL NEED

- ☐ A 20 x 16in (51 x 41cm) sheet of smooth drawing paper
- ☐ A drawing board
- ☐ A ruler
- ☐ Two black fine-line drawing pens – one old and one new

▶ **5** Now you can start on the wall itself. Note how the water has washed away whole patches of plaster and eroded the bricks beneath. This irregularity is to your advantage since you won't have to embark on the laborious task of replicating identical bricks.

So have some fun mixing scribbled strokes with hatching and cross-hatching. Work the pen in different directions for different bricks and use a ruler to define the outlines of some of the bricks – and not others. When you stand back from your picture, the overall effect will be of a crumbling wall.

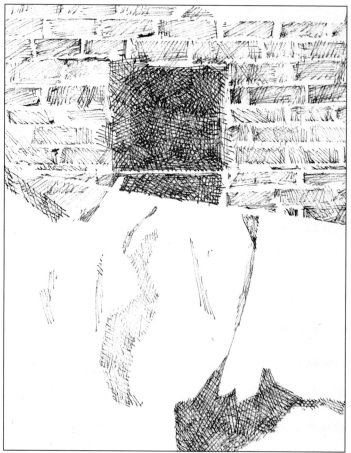

6 If you become tired with putting in the bricks, there's no reason why you can't jump to another area of the picture. For instance, switch to the old pen to scribble lightly across the plasterwork area. This gives a good impression of cracks and texture.

7 Return to the new pen to fill in the deep blacks for the window on the right. Then switch to the old pen to finish the lighter areas of the window, the outline of the shutters and the rest of the brickwork. Once again, use a combination of loose hatching and precise ruler-aided work.

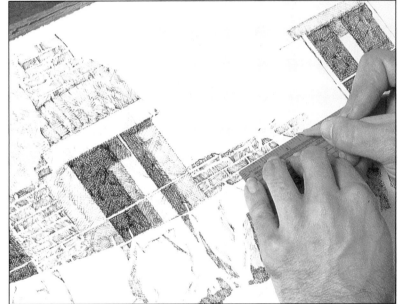

8 Now that the brickwork is rather more advanced, the shadows of the shirts are slightly lost. Return to the new pen to hatch over the shadows again. Emphasizing these shadows puts the shirts into bold relief.

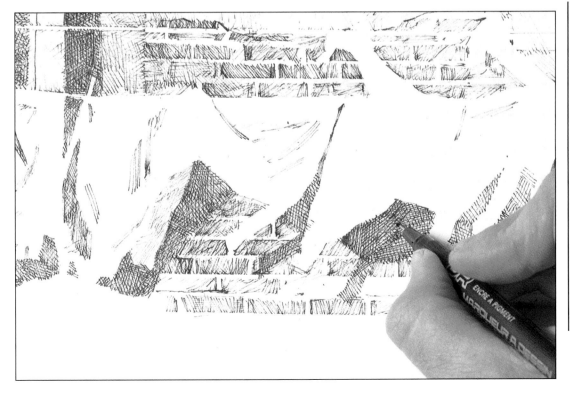

▶**9** Below the clothesline, water has eroded the wall, so you can be fairly loose with your pen marks. Use a combination of hatching, cross-hatching and scribbling – making sure, though, that you keep referring back to your reference for accuracy.

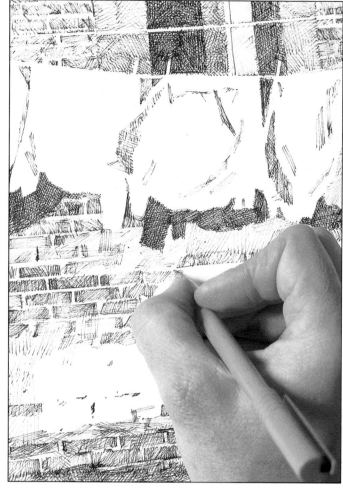

▼**10** Carry on working down the picture until you reach the water. Use dense cross-hatched stokes for the damp stretch of wall at the bottom – this gives your picture a bold baseline and helps 'ground' the drawing.

 The picture is now finished – don't be tempted to take it any further. Note how little shading, for instance, has been included on the white shirts. This makes them stand out against the wall – just as they did in real life. Also look at the way the patches of plaster have been indicated by a few loose, scribbled strokes of the old pen.

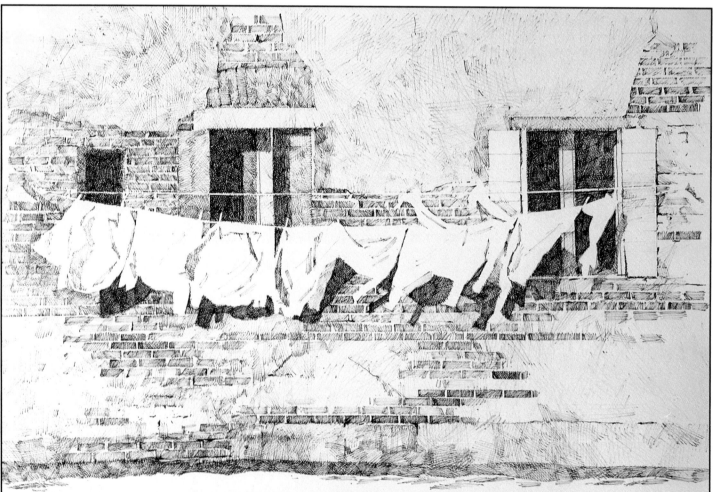

Tonal washes

Mixing a graded range of ink washes and using them to identify areas of tone in a subject is a useful exercise which will help you establish tonal values.

A pen-and-ink line can be used not only to explain shape, but also to suggest form and tone in a drawing. However, since the pen is a linear medium, this can make for a time-consuming, or size-limiting exercise. By using a brush to sweep in broad areas of tone with ink or watercolour washes, your artistic possibilities are extended both in terms of freedom and scale.

It is all too easy to become distracted by detail, or to be confused by colour (which has its own tonal value), rather than establishing the general scheme first. So a methodical approach to applying tonal washes is a useful way of analyzing the broad tonal values of your subject. In a typical landscape scene it is easy to identify the distant paler tones and darker foreground tones, but in an interior scene this may be more difficult.

To get this aspect of good picture-making right, you have to seek out the tones actively. The best way of doing this is to squint at your subject to pick up the main differences. Don't worry about tiny variations – try to distinguish between just half a dozen or so tones at first. Make it a mechanical part of your drawing or painting session by squinting at the set-up before adding each new colour or tone.

▼ Tonal studies like this are easy to make on site. Instead of mixing the ink tones in advance, simply dilute your ink thinly to start with, then use stronger and stronger mixes until you achieve a rich, deep tone, such as that on the foreground trees here. Your finished study will have a moody atmosphere, like that of a black-and-white photograph. *'Lake Scene' by Emma Ronay, ink washes on paper, 12 x 16½in (30 x 42cm)*

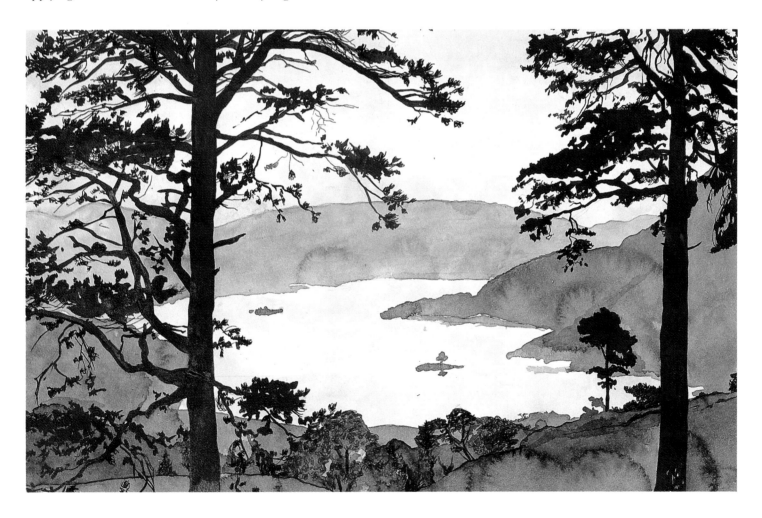

By the fireside

Black waterproof ink should be used for this exercise. This will allow you to work over washes once they are dry to give a crisp edge to subsequent washes, or to work into the washes while they are still wet, creating blended edges. The artist used Chinese ink, but you can also use Indian ink; use distilled water to dilute the ink. You will need to mix up seven washes of different dilutions. Make sure that you test them before you use them, and mix enough of each.

The artist seeks out each tone in her set-up, working methodically from light to dark. This way of working forces you to look at the subject as a whole, making you much more aware of the composition. Later on you'll be able to work more freely, flitting from light to dark tones.

YOU WILL NEED

- ☐ A 12 x 18in (30 x 46cm) sheet of thick smooth drawing paper
- ☐ Seven small containers (glass jars or yoghurt pots) and a large container of distilled water
- ☐ An HB or B pencil
- ☐ Tissues
- ☐ Scrap paper
- ☐ A fine-nibbed dip pen
- ☐ Two brushes: a No.9 round watercolour brush and a small rigger or liner
- ☐ A bottle of black Chinese ink

The set-up The artist worked from a sketch that she had made earlier of her pet cats. Either use her finished picture as your reference or, better still, draw a scene from your own home.

▶ **1** In your seven containers mix seven tones of Chinese ink. The lightest should have the merest hint of ink, while the darkest should be near-black. Test the diluted ink on scrap paper to make sure that you have an even range of tones.

Carefully pencil in the composition, then start applying your palest tone (No. 7) to the lightest areas with the No.9 brush, leaving white paper for the brightest highlights.

◀ **2** Working from light to dark, now move on to the second lightest tone (No.6). Squint at your set-up to see where it should be applied. The artist used it to delineate the fireplace and to put in the shadows on the chair and behind the cat on the right. She also used it for the markings on the left cat (see step 3). Apply this tone twice to the front edge of the chair cushion to produce a slightly darker tone here.

▶ **3** Switch to the No.4 ink to put in the middle tone in the set-up. Look for the shape of each area of tone – it's unlikely to correspond with the lines of your pencil drawing. Some tones will cross the edges of forms into the shadows behind them, others with cover only part of an object.

The artist used the No.4 tone on the fireplace surround and the shadow at the top left of the chair back. For the chair back tone, she first painted the area with clean water and then flooded the ink into it for a soft effect. She used a paper tissue to dab off ink so that it merges with the surrounding areas.

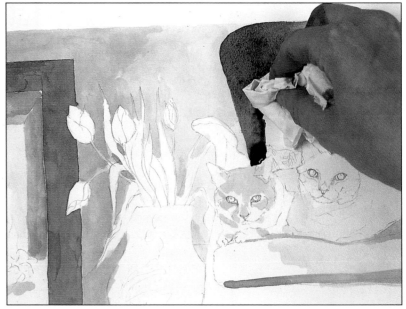

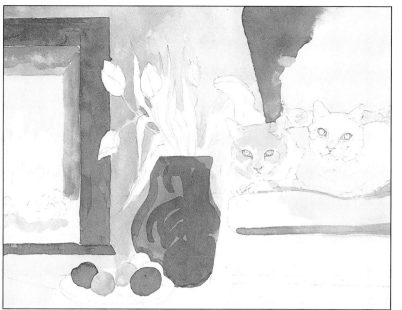

4 Continue to put in the mid-tones as necessary. The artist used the same ink wash on the vase and fruits, applying it a second time to denote the shadows on the side of the vase and to distinguish some fruits from the others. Overlaying a second wash of the same tone will produce an intermediary tone between that dilution of ink and the next dilution.

5 Now the artist used her No.3 ink dilution for the deeper tones on the vase and the leaves and stems of the tulips. She switched back to the No.4 tone for the patterning on the right. It's very good practice to do this – once you become more adept at distinguishing the tones, you can play about as much as you like, applying dark and light tones, then working towards the middle.

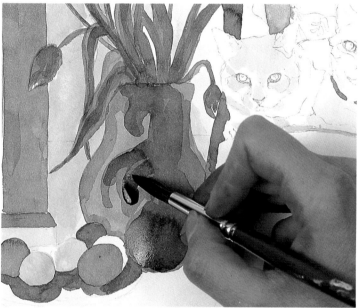

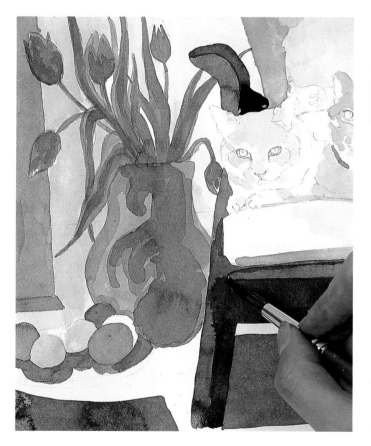

6 The artist used the No.3 wash for the tone of the carpet, then switched to the No.2 and No.1 tones. Look very carefully at your subject before applying these very dark grey-blacks – you can't do much with them if you misplace them, but in emergency you can dab them off with the tissue straight away.

You'll find that you get the best results if you try to forget what you are painting and instead isolate the shapes of the tones as if they are part of an abstract pattern. Then when you stand back, your picture looks just like the subject.

Switch to your lighter tones for the fire blazing away in the fireplace.

▶**7** Once you've blocked in all the large areas of tone you can start to add detail. The artist used a rigger for this, but you could use a good-quality round sable brush with a fine tip or a liner brush. She added the markings on the cats with this brush, then switched to a dip pen for the very fine lines – around the eyes and on the noses of the cats, for example.

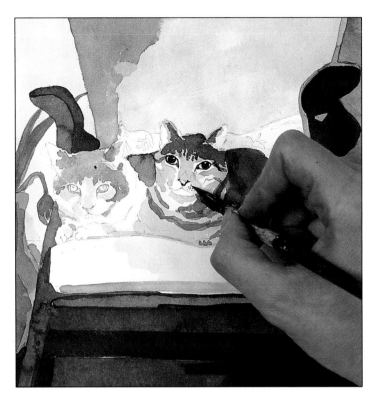

▼**8** Make any last-minute adjustments, then your picture is finished. You can create some appealing images in this way, but you'll also find your picture makes an excellent preliminary tonal study for a painting. And if your picture doesn't work as well as the artist's, learn by your mistakes. You can go on to make a painting from your picture, correcting any tonal errors as you do so.

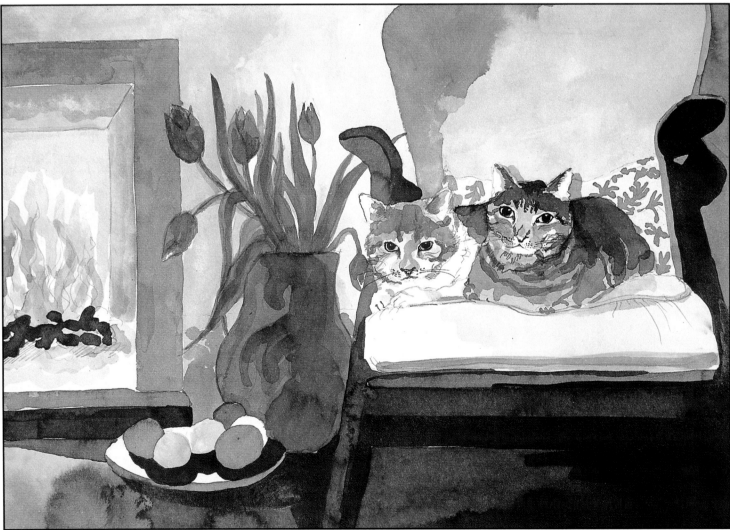

Mixing media

Pen and ink is an ideal medium for drawing buildings and architectural details; other media such as pencils, pastels or charcoal can combine well to suggest texture.

The precise and linear quality of architecture, together perhaps with a subconscious memory of architect's working drawings, encourages us to make pen and ink an obvious choice of medium when drawing buildings. Technical pens give greater precision than many other pens, but you may also wish to try dip pen and ink, or one of the many fine-line drawing pens available, or perhaps ballpoint pen.

When it comes to depicting the textures of building materials, pen and ink and washes can be used, but it is worth exploring the option of employing a different range of media, which may be more suited to the task. Grainy materials, such as pencil, charcoal and pastels can often create the required effect quite effortlessly, and texture of the paper also plays a part in the character of the marks produced.

One of the great advantages when it comes to sketching buildings is that they stay put. Having said this, though, don't imagine for a minute that buildings are boring. Endless visual excitement and interest comes ready-made in most towns and cities where buildings of all ages jostle each other shoulder to shoulder. Look around and you'll see any number of interesting examples.

It's not only the style of buildings that draws the artist's eye. Details – of stonework, towers, plasterwork decoration, doorways and wrought-iron – offer fascinating patterns and shapes which make interesting drawings. The materials that buildings are made from – grey or honey-coloured stone, marble, bricks and mortar, stucco, wood and concrete – provide a whole array of colours, textures and weathered effects. The play of sunlight and shadow on walls, roofs and windows, through the different seasons, offers another dimension to intrigue any artist.

▲ A panoramic, high eye-level composition captures a slice of this Mediterranean coastal town. A technical pen is ideal for detailed, interlocking lines like these – dramatic diagonals and aspiring verticals, with the horizontals creating separate planes that give the sketch great depth.

Note how the artist treats the rocks and sea differently, with ink washes, giving a sense of their organic textures.

► Showing space and distance is easier with an understanding of aerial perspective – things become lighter as you move farther into the background. Although the hill is represented as a dark object, the smudges are light against the middleground foliage, and lighter still compared with the rich band of shadow in the foreground which makes the roof advance.

It's interesting to note that the artist, perhaps subconsciously, drew the natural materials (such as the clay pantiles of the roof) and the organic matter mostly with a pencil, but put in the man-made structures with a technical pen.

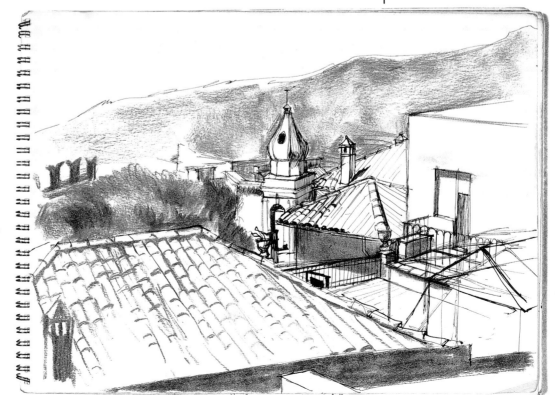

All drawings on this and the previous page are from the sketchbooks of Anne Wright

Some practical points

Use your pen as a measuring tool to help you get proportions right and to check perspective. Make sure you've drawn your angles correctly by holding your pencil up along an angled line on your subject (parallel to you), then, keeping it at the same slant, move it down to your page to compare it to that line in your sketch. It's vital that you get perspective right – buildings are so familiar to us that mistakes tend to stick out like a sore thumb.

▲ Sometimes the perfect viewpoint simply presents itself. Here, the artist stumbled over a compositional gift! The intriguing steps take your eye up to the energetic middleground and on to the roof of the church. Its tiny spire stands out effectively in the distance.

▲ A good assessment of tone brings this quiet back street to life. The shadows lead your eye along the path to the light area where a gap between the buildings allows the sun to shine through.

The artist has mixed her media skilfully here. She uses pencil, pen, and ink washes to describe the different tones.

◀ This stone building is marvellously expressed through tones, with line holding the details and edges together. The artist conveys not only a sense of its strong structure, but also the texture of the stone. Whatever a building is made of, suggesting its texture can only add conviction to your work. Note how the artist left the pantiles on the foreground building incomplete, so that the focus remains on the stone structure.

Textural tones

Pen and ink is a lovely medium for landscapes – the infinite variety of marks you can make enable you to create the wide range of tones and textures inherent in the natural world.

The particular beauty of drawing with pen and ink is that it is so immediate – all you have to work with is the white of the paper and the infinitely variable line made by the ink as it flows from the nib. Part of the skill lies in the fact that every mark you make counts: unlike pencil drawing, you can't easily erase ink – each line, dot and stroke is there to stay.

Tones and textures are built up gradually by going over the same areas again and again with the pen nib. In the landscape shown on these pages, you can see that the lightest areas require deft, delicate strokes, but the darkest areas have been positively scrubbed on. The secret is to start tentatively, lightly dotting in the main outlines, and then increase the emphasis and strength of your marks little by little as you become more confident. Remember to work over all areas of the drawing so that you can balance the weight of tone and texture.

Note in this demonstration that the artist hasn't simply copied his detailed pencil study stroke for stroke – something which is very tempting for the amateur artist to do. Throughout, he has found new ways of successfully rendering a tone or texture, and in the process, he shows his mastery of both pencil, and pen and ink.

YOU WILL NEED

- [] *A 15 x 11in sheet of 140lb (300gsm) hot-pressed watercolour paper*
- [] *A table easel*
- [] *A drawing board and tape*
- [] *Paper tissues for wiping the pen nib*
- [] *A dip pen and nib*
- [] *A bottle of waterproof black Indian ink*

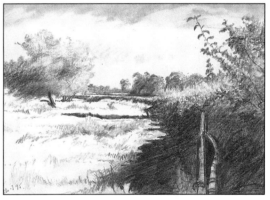

▶ **The set-up** This artist is a compulsive sketcher, so he's never at a loss for a subject.

Here, he was attracted by the huge tonal range in the subject which demanded careful observation to depict accurately.

◀ **1** Start drawing straight away with the dip pen and ink (try to resist the temptation of starting with a faint pencil outline). Plot the gate on the right with light, tentative, broken lines – don't state anything too firmly at this stage; leave your options open for alteration later on. Putting in the top of the gate first, helps to locate all the other parts of the drawing.

Plot the main contours of the scene in small, delicate dots and lines. The aim is to establish accurate positions for all the main objects in the picture – the gate, the trees, the hedge and so on.

▲ 2 Start to indicate the patterns in the grass as you continue to develop the picture. Fill in here and there with short upright strokes of the pen to represent blades of grass and small uneven tufts. Vary your marks as much as you can.

Note where the light is coming from and indicate a few tonal variations as you develop all areas of the picture, still working lightly.

▶ 3 Add detail to the hedgerow on the right. At the moment these are the darkest tones in the whole drawing. Note the different textures here which give a vital element of life to the drawing early on. Short, scribbled strokes and sturdy hatching give a strong, dark, energetic mark, while looser lines provide a more general tone.

▶ 4 Continue building up a few very dark tones on the foliage to the right of the gate with vigorous hatching and cross-hatching. Note the little semi-circular lines which give shape to the gatepost.

This dark side of the drawing needs a lot of work. The other side is in sunlight, so the marks made there are much lighter and more delicate.

Tip

Strong and sturdy

To achieve the strong, dark tones in this drawing, you need to hatch and scribble with some vigour. The paper must therefore be fairly thick and sturdy to withstand a considerable assault from the pen nib. The artist used 140lb (300gsm) hot-pressed paper which was heavy enough not to break up under the nib, and yet smooth enough to allow the pen to glide over it with ease.

◀ 5 Start filling in between the gate with some darker cross-hatching. This, and the area of shadow under the hedge, is going to be the darkest part of the whole drawing, so the artist wanted to establish it early on to give him some very positive tonal values to work on.

Start to define the foliage on the far right, keeping an eye on the balance of tones at all times.

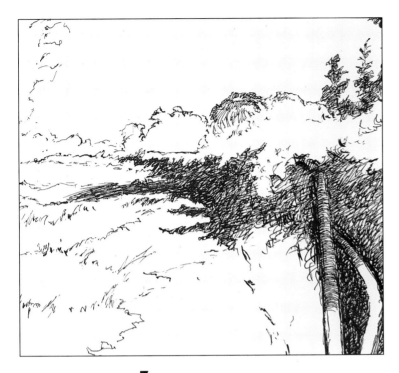

◄6 Continue hatching on both sides of the gate on the right. Build up the structures here, gradually bringing the darks farther out to the left. Note the very dark hatching on the lower right area.

If you scrutinize the marks made in the dark areas on the right, you'll see they are built up with lots of squiggles, circles, hatching and scribbles – the artist goes over the same area again and again with the pen to build up depth of tone and texture. He leaves little flecks of white paper showing through the increasingly intricate network of pen-and-ink lines to ensure that he doesn't deaden these areas.

►7 Now move on to the big tree on the left. Start hatching in the foliage here in the same way that you did for the hedge on the right. Aim for different tones and textures. Closer, darker hatching in some areas (such as the lower boughs on the left side of the tree) contrast with lighter marks farther apart higher up the tree on the right side. The trunk is put in with very dark, strong strokes.

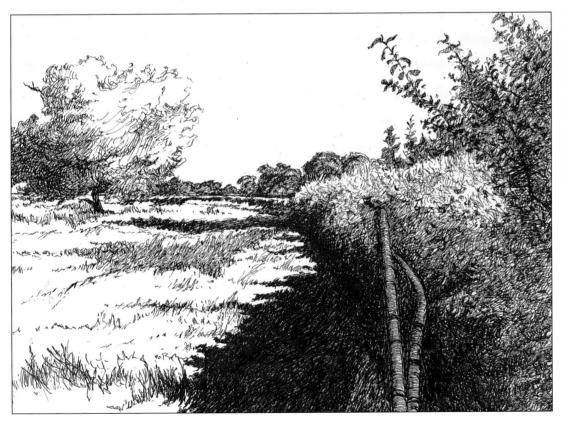

◄8 Carry on scribbling, hatching and cross-hatching all over the picture. Put in the grass in the centre (note how the lines are spaced fairly far apart here to give a mid-grey tone), and build up the big tree on the left a little more, along with the hedges and bushes in the background. Beef up the dark line of shadow under the hedge once again, pressing the pen nib on to the paper with purpose for some very rich, dark marks.

▶ **9** Start putting in the sky above the clouds in long loose strokes of the pen.

Darken the darker side of the big tree, again by scribbling with as much firmness and strength as the paper will take. Bear in mind that where, in the pencil sketch, the tones are smudged in, you must use a completely different technique with pen and ink – long, slanting strokes, which achieve the same kind of middle tone as the smudging.

▼ **10** Adjust the shape of the clouds with your pen, re-drawing and moulding them as you go. Note the wide variety of different strokes – long, short, straight, slanting, dotted, tufted and scribbled. Bring on details here and there across the picture – darken the tufts of grass under the hedge, for instance.

In the final drawing, the subtle variations of tone produce an excellent sense of recession and give the picture a great deal of delicacy. The artist has taken great pains to ensure that there is considerable variety in his marks which give the drawing vigour and help to lead the eye across and into the picture.

Note the extreme contrast between the lightest lights and darkest darks, with several shades of grey in between. This is what makes the drawing ultimately effective as a tonal study.

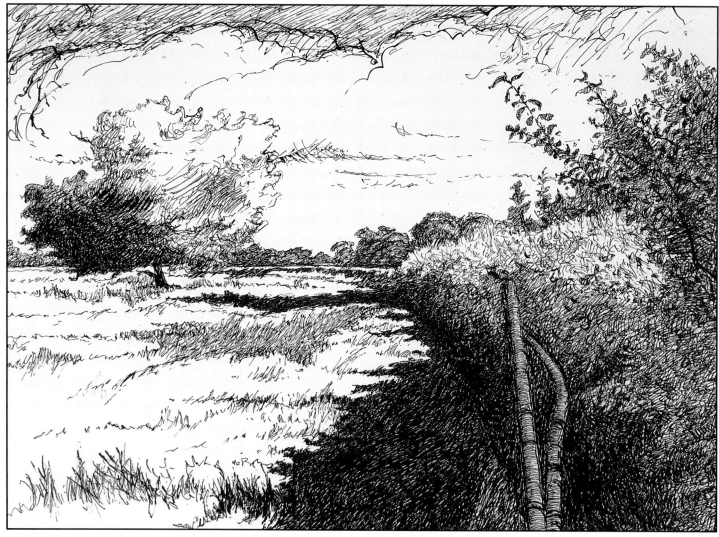

Line and tonal wash

Combine the crisp, incisive qualities of pen and ink with the soft, tonal qualities of brushed-on ink or watercolour paint.

Pen and wash is a traditional technique with a fine pedigree and, in the hands of a master draughtsman such as Rembrandt, yields results that appear delightfully simple.

The practical advantage of combining wash with line is that the washes free you from having to shade with the pen with hatching, cross-hatching or stippling to render tones. With line and wash you can use the washes to shade, and enjoy the wonderful variety of pen marks to describe contours, outlines and textures.

In a monochrome picture, the line and wash are the same colour. So typically you might use a dip pen, or a reed or bamboo pen, to draw in Indian ink, brushing in washes of dilute Indian ink as you work. On white paper, this results in a range of tones – from the white of the paper, through the greys of the washes to the dense black of the pen lines. Other neutral colours, such as sepia ink, or Payne's gray watercolour can be used to good effect.

To start with, use a waterproof ink, such as Indian ink. This way the ink won't run when you apply the washes. (Later you can try washing over non-waterproof inks to produce wonderfully diffuse puddling and pooling effects.) A dip pen with a steel nib is ideal. If you prefer to use a fountain pen, make sure that it is designed for use with waterproof ink – most are not.

Dilute watercolour paint, such as lamp black, can also be used for the washes (at least to start with). Watercolour paint is more forgiving than waterproof Indian ink which, even when dilute, can't be moved with the brush once dry.

Finally, there's something about the quality of an ink line that commends a spontaneous approach. Not that the medium excuses poor drawing – it just tends to reward the brave and the bold and punish the tentative. So be bold!

▼ **Monochrome ink or watercolour washes go hand-in-glove with ink drawing. But it's important to stress that the pen and brush work should be integrated – you don't want a line drawing that is merely 'filled in' with washes. Here, you can see that the brush has done most of the work and the pen is used mainly to emphasize important outlines.**
'The Trio' by Audrey Hammond, pen and ink and wash with body colour, 11 x 15in (28 x 38cm)

YOU WILL NEED

- ☐ A dip pen or fountain pen capable of taking waterproof ink
- ☐ A No.6 sable brush (the artist used a Chinese brush)
- ☐ A sheet of heavy smooth drawing paper
- ☐ Waterproof Indian ink
- ☐ Lamp black watercolour paint
- ☐ Water (distilled if you are diluting Indian ink)

Seated girl

▶ **The set-up** The artist chose to draw a figure – a subject he is fond of, and one which lends itself well to the pen-and-wash technique. It should be said that he is highly experienced at figure drawing in pen and ink. So if this is your first attempt, don't expect to make a drawing of comparable quality! However, you can get yourself off to a good start with a bit of careful preparation.

Choose a simple pose. (The artist recommends a sitting one.) Try out your pen – get a feel for its weight and the flow of ink. If you feel you need extra guidance, you could make a pencil drawing at this stage (but remember to use it only as a guide and don't trace over it).

▲ **1** Dilute some lamp black. Drawing loosely with the brush, use wash and line to make a faint underdrawing. Suggest a few of the planes – the wall and waistcoat and the side of the face – in washes, then pick out contours and outlines with a slightly darker line.

▲ **2** Look carefully – try to see the line that best describes what you see, then commit yourself to it. (You can over-ride these lines with ink later.) To soften a line, let the paint dry slightly, then wash over it with water – it's hard to see, but that's what the artist is doing here.

▲ **3** Build your drawing without labouring and overworking it. Stick mainly to line at this stage, keeping most of the paper untouched. This way you'll be able to leave crisp white highlights later. (This is like watercolour painting in that you work from light to dark.)

◀ **4** With the major forms – such as the head and neck, torso, arms, hands, legs and feet, wall and floor – in place, use your pen to rediscover the contours. Don't trace over the brush lines. Look at your model and let what you see guide you. (If the lines happen to coincide, all well and good!)

Stop here and there to explore an eye or the hair, say, in more detail. You might want to soften some of the pen lines around the eyes using a wet brush, as the artist has done here.

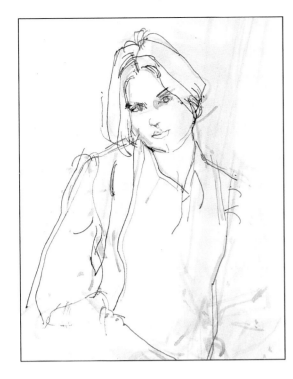

5 It might take several attempts to put a line in the right place – don't worry. The whole process is one of correction. You put a line in and try to find something wrong with it – when you can no longer do so, you've got it right! The final version speaks for itself and the 'wrong' lines often add to the drawing. Here, you can see where lines have been replaced.

6 You can't coax ink on to the paper in the way that you can with pencil. When you meet a tricky part – such as the hands and fingers here – look carefully to see what's going on and then go for it! Creases, folds, seams and the edges of clothing provide useful contours. (The artist has used the curve of the cuff to describe the cylindrical form of the wrist within.)

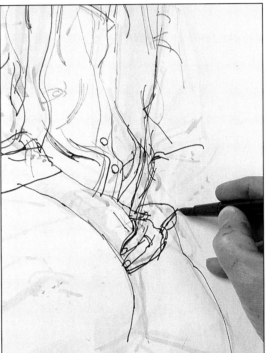

Tip

Big head, little legs
To prevent the paint and the ink from running down the page, work on a near-horizontal surface, such as a table top or table easel inclined at only a slight angle. Lean over your drawing as you work, so that you get an undistorted view. This should help to correct any tendency to make the top half of your drawing disproportionately larger than the bottom.

7 Your dense black ink lines will make any earlier mistakes pale into insignificance. But don't take the ink drawing too far at this stage – leave yourself some brush work (if you go too far now, there's no turning back). You can always return to the pen later. Leave the ink to dry – and, while you are waiting, study your subject, looking for places to use some darker washes.

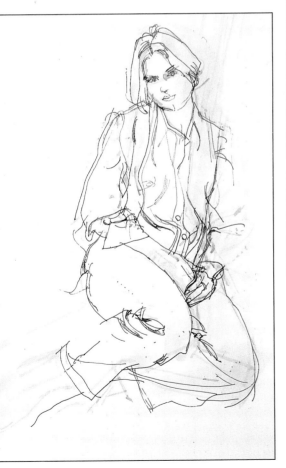

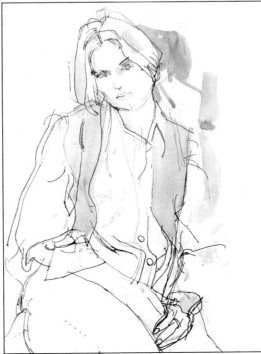

8 Dense shadows are obvious candidates for the darker washes, but often forms turn away quite gently from the light, creating more subtle tones. You can even represent colour if you wish.
 Here, a dark wash at the side of the model's head lifts her head away from the wall. A paler wash on her waistcoat tells you it has a different colour from her shirt. Whatever you do, resist the temptation to 'colour in' your ink drawing without looking at your subject.

9 Where you want to make the tones darker, go over them again but let the previous wash dry first. Avoid encroaching on crisp, white areas – particularly those on the face. It's easy to cut back highlights on the cheeks, nose, chin and forehead too far without even noticing until it's too late. If anything, it's best to understate the tones and let the ink lines do most of the work.

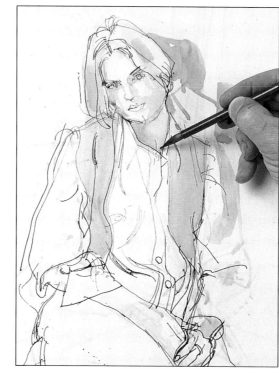

▲10 For large banks of shadow – like the one in the foreground on the model's legs – load your brush with plenty of paint and turn it on its side. This way you can cover the paper quickly and boldly, keeping the effect loose and lively. Make sure the paint is completely dry before going on to the next stage.

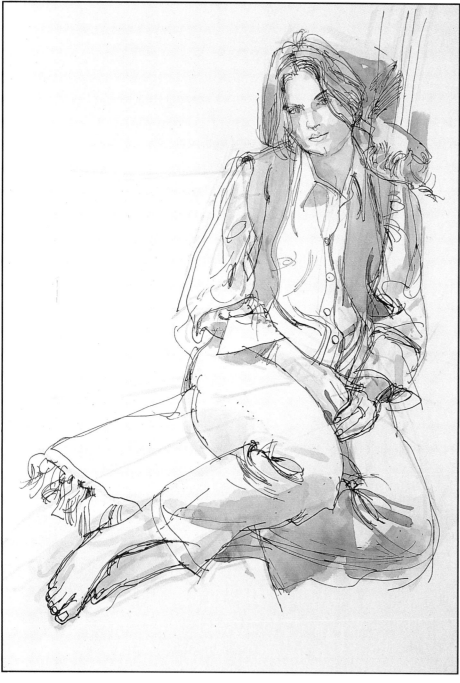

▲11 Finally, strengthen your drawing by going back over some of the contours with your pen.

Here, the artist emphasizes the curving folds down the inside of the model's left arm and strengthens the shadow inside the cuff with a few rolling strokes. This is a good point at which to hint at textures and peripheral details.

◄12 Just a few pen strokes tell you how the model's hair falls, but not to the extent that the hair no longer looks blonde. A brief indication of the cushion on which she is sitting, and the one that supports her head, helps to anchor the figure so that it doesn't float in mid-air. Note, in particular, this charming drawing's crispness and spontaneity – qualities typical of pen and wash.

Warm and cool greys

Marker pens come in some very bright colours, but don't neglect the greys – they give you a full range of tones for working in monochrome.

Marker pens offer a comprehensive range of greys – light to dark in both cool and warm shades. Often these are used in conjunction with coloured markers to provide the grey tones in a drawing, or to overlay colours for shadows. But grey markers used by themselves are excellent for monochromatic drawings. With a variety of tones, you can mould forms and create a sense of distance, just as you would with a graphite pencil.

You don't need many greys for working tonally. By overlaying it's possible to create a range of tonal values with a single marker. Five or six different greys – both warm and cool – are enough for most purposes. Use a spare sheet of bleedproof marker paper to test the value of each grey before you commit yourself to making marks.

It's important to remember that marker ink is transparent. Like watercolours, you build up tones by overlaying, beginning with the lightest greys and working gradually towards the darks.

Chisel-tipped markers make a variety of lines from thin to thick. You can also use the shape of the tip to create the blocky marks used here to describe the buildings of Florence.

▼ This detail shows clearly how pale tones recede into the distance, while the warm roofs advance. Note how, on the round windows of the dome, the different greys and the highlights give depth to the recesses. As you can see, chisel-tipped markers are perfectly shaped for the angularities of roofs, windows and architectural designs.

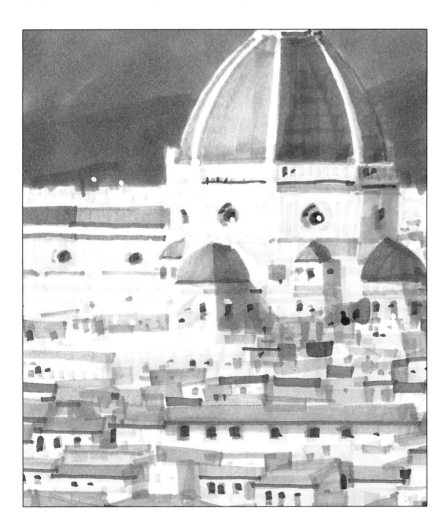

A view of Florence

◄1 Because the artist's subject – a view of Florence – is quite a complex one, he made a detailed drawing first to use as a guide. Make this drawing on the next sheet of paper in your pad from the one you intend to use for your marker drawing (see step 2).

Draw the elements of your subject with the 3B graphite pencil, aiming to establish all the shapes so you can block them in with markers. Here, the artist draws in the outlines of all the buildings, the windows and the distant hills.

►2 Turn back the sheet of paper to the one that you'll be working on. Because marker paper is so thin, you can see your drawing through the paper and use it as a skeleton to build from.

This system is especially useful for markers since the marks are not easily corrected. With the pencil lines on the paper beneath, you have a better chance of getting your drawing right first time.

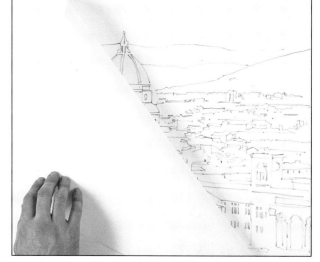

▼3 Give the drawing form using cool grey 1. Block in the roofs, the windows and the shadows on the buildings (let the white paper indicate the sunny sides). Don't worry about mistakes at this point – this pale grey can be incorporated or covered as you work darker.

For, say, shadows on walls, use the flat tip to lay broad bands of tone, placing these side-by-side for large expanses. Use the flat to make short strokes for the windows, and the very tip for thin lines and dots for distant windows. For the roofs, start with a thin outline, then fill in with broad marks.

▼4 Once you've finished this first layer of tone, work back over your tones with cool grey 1 to darken them and to define details. Develop the background less than the foreground and middleground to create a sense of distance.

Because the dome is a focal point, concentrate on bringing out its architectural details.

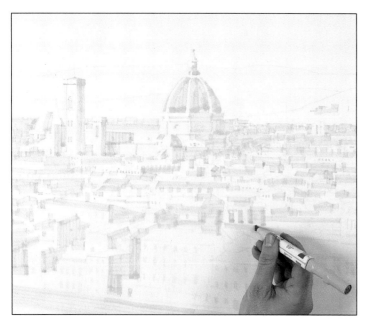

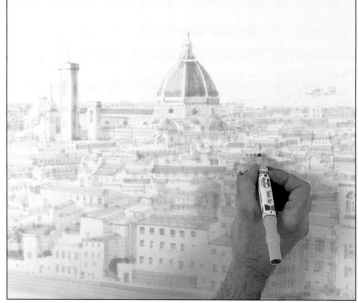

◄5 Darken the roofs with warm grey 4. Note how, as you get darker, the details of the drawing become crisper. Make sure you use continuous straight lines for the roofs so that the marks you make remain constant. If you hesitate halfway through a line, you'll create a slightly darker tone in that area.

▲6 Aim to make the roofs warm and the walls cool, so the viewer can differentiate between them easily. The artist felt that warm grey 6 approximated to the warmth and tone of the terracotta roof tiles.

If working from your own reference, keep looking at it with hooded eyes, comparing tones with each other. It's also a good idea to keep stepping back from your drawing to see if the tones are balanced.

Put in some of the darker and shaded roofs with warm grey 6, then use the same marker to pick out the rooftop edges.

◄7 Develop the walls of the buildings. Use cool grey 4 to darken shadows on the walls and under the eaves of the roofs. Once you've done this, you'll need to deepen the tones of the windows with the same marker.

►8 Dip a clean transorb in Minoan grey ink. (This is actually a mid-blue.) Use the side of the transorb to create broad marks to cover the sky and hill area, taking care to avoid the outlines of the buildings and the small area for the house on the hill.

Now use the nib of the Minoan grey marker to overlay the hills – this pulls them out in front of the sky. Overlay the nearest hill yet again, this time with cool grey 5. If necessary, use cool grey 5 to darken some of the windows around the drawing.

▶ 9 To complete the picture, you need to put in the darkest tones. Deepen the shadows around the drawing, especially those in the windows, with cool grey 7. When working on each building, don't darken all the windows – the variety adds interest. Then add some fine touches of highlight with the corrector marker – on some of the windows and around the house on the hill, for instance.

▼ 10 At this stage, the artist decided that the sky was too dark, especially against the hills. In a bold move, he used the corrector marker to scribble loosely all over the sky area. Don't worry that some of the blue shows through – broken colour only improves the sky effect. Now squirt some lighter fluid on to a clean transorb and use this to blend the white marks in the sky. This lightens it considerably, pulling the hills forwards. (Always use lighter fluid with caution.)

▼ 11 Add the finishing details. Put in the part of the river visible on the left side with overlaid strokes of Minoan grey for varying tones, then dot on some white with the corrector marker to indicate foamy water. Work around the picture, tidying up the shadows.

The blue-grey Minoan grey is the only touch of colour here, yet the drawing is lively. The variety of greys bring out this vista of Florence with its jumble of buildings – you can almost feel the activity going on at ground level. The tones create a good sense of space and form.

Stippling

If you find pleasure in meditative tasks, you may like to try stippling. This technique of building up tone relies on a slow, methodical approach.

Stippling is a very well established and much favoured pen-and-ink technique. Its appeal has much to do with its simplicity. A simple dot, placed next to another, and another and another, slowly develops into a full and complex image, with a strong sense of tone and three-dimensional form.

The technique is not only simple in theory – it's straightforward in application too. You can use the point of any pen to make a series of dots. From a distance, these combine to create a tone. By changing the size of the dots, and/or the spacing between them, you can create a full range of tones from light to dark. For instance, large dots placed very closely together form a rich, dense, dark tone. If you space smaller ones farther apart, you make a very pale, delicate tone.

The irregular flecks or dots of a dip pen result in an appealing, uneven look. For a more regular effect, use a technical pen such as the one used here by the artist.

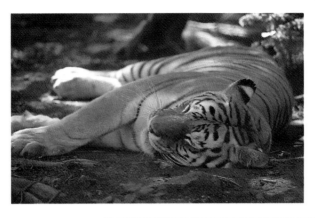

◄ **The set-up** The best type of subject for stippling is one with a wide range of tones and a good contrast between light and dark. The artist chose this tiger for exactly these reasons. Its dark stripes create a strong contrast against the lighter fur, and the variety of mid tones provide plenty of scope for stippling. The fur allowed for some interesting texture-making as well.

► **1** Using the pencil, lightly sketch the tiger's outlines and position the stripes and facial features. Now begin to stipple in the darkest areas with the 0.35 pen, starting with the darkest areas on the face. Spacing the dots quite close together with this larger pen creates dark tones. As you work to the edge of the stripes and shadows, space the dots farther apart, to make it look as if the dark tones peter out into the lighter surroundings.

Don't make all the dark tones the same – vary them to bring out the shadowed planes of the face.

◄ **2** The artist chose to work on the face first, since this was the focal point and the closest point to the picture plane. Once you've put in the dark areas of the face, begin working up the stripes on the body, making them follow the form of the tiger to suggest the rounded shape of trunk and legs.

Now switch to the finer 0.18 pen and return to the face to build up some fine shading on the lower, shadowed side. Use these finer tones to mould the planes of the face even more.

YOU WILL NEED

- ☐ A 12 x 18in (30 x 46cm) sheet of CS10 paper (or CS10 lineboard or smooth drawing paper)
- ☐ A hard pencil
- ☐ Two Rotring pens: 0.35mm and 0.18mm
- ☐ A craft knife

► **3** With the 0.18 pen, continue fine shading on the head, especially around the eyes and nose.

Note how the artist deals with the nose. She uses a closely placed line of dots to define the shape of the right side of the nose against the rest of the face; she leaves areas of the paper blank for the highlights; pale tones along the middle of the nose are indicated with widely spaced fine dots; the darker shadow on the tiger's left side is put in with a denser population of dots; the pores for the whiskers are made darker still, the artist stippling in the tones carefully to catch their irregular shapes. All this attention to detail brings the nose to life, giving a strong sense of its form.

Start putting fine shading on parts of the body too, to bring out the round form of the trunk.

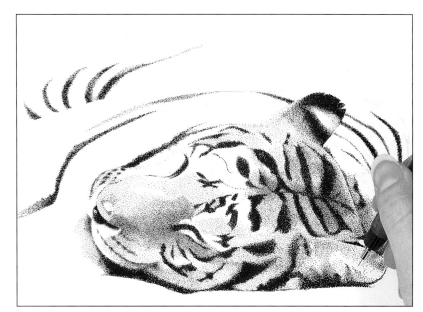

◄ **4** Look at the photograph. The ear closest to the ground has a few long whiskery hairs which are lighter in tone than the shorter fur. To show this, you first need to make the shorter fur as dark as it needs to be with plenty of shading (far left).

Using a sharp craft knife, lightly scrape out the pale, whiskery hairs, making gentle arc movements (left). Go over the same lines until they are as thick as you want them to be, taking care not to tear the paper. Turn your picture on its side if you find this position more comfortable.

► **5** Stay with the 0.18 pen to extend the fine shading to the body in between the stripes. The artist concentrated on the shoulder and top of the front legs, putting in some of the smaller, paler stripes on the upper leg at the same time.

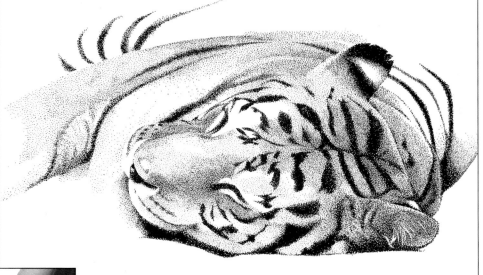

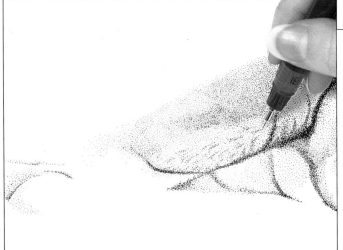

◄ **6** Stipple down the front legs, building up more detail. Work as you did before, using the 0.35 pen for shadows and dark stripes, and the 0.18 for the fine shading. Use the finer pen to make a series of dots and tiny lines to create the furry effect along the leg.

Halfway through the upper front leg, the artist switched to the paw to do a little fine work there, before returning to the upper leg. She finds it easier to work on the focal points and join them together, rather than working systematically along the whole length of one leg.

7 Using the 0.35 pen, put in the rest of the thick black stripes on the tiger's back, again making sure they follow the rounded form of the body. Look again at the photograph – the stripes farther back along the body are just as dark as the closer ones, only they are a little out of focus. To indicate this, make the distant stripes lighter.

Where she wanted to obtain a furry effect, and create a delicate gradation of tones within the stripes, the artist used the larger pen for the central dots, spacing them farther apart as she worked towards the edges of the stripes, then switching to the finer pen around the edges.

Continue fine shading on areas of the front half of the tiger. Build up quite a dense covering of dots on the back as you move towards the floor to deepen the tone in this area.

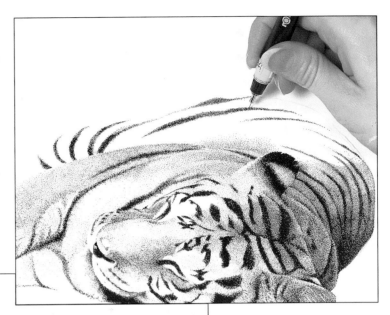

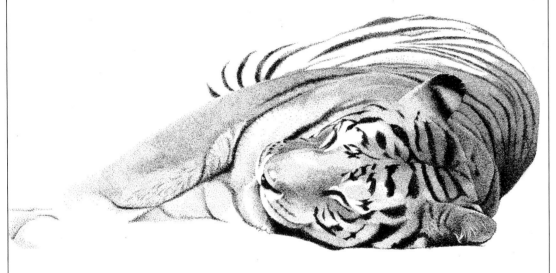

8 Once you've put in all the stripes, stand back to assess the success of your drawing. It doesn't matter if you haven't reproduced the stripes completely accurately, as long as they appear to go around the tiger's body and help to describe its form.

Note how the artist has left a fine highlight along the upper edge of the most visible front leg to show the way the light strikes the tiger. This adds to the successful contrast between light and dark areas in the drawing.

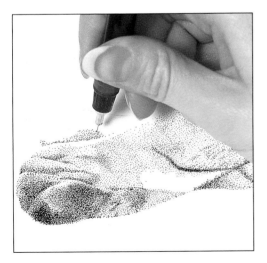

9 Continue the front paw, extending it to connect with the marks on the upper leg so they blend. Work up the end of the paw which you can see behind the other one too. For both paws, start with fine shading with the 0.18 pen, placing the dots closer together for the darker tones.

10 Stand back and take a good look. The front half of the tiger is almost complete, and because you have more or less an overall picture of this area, you can pick out where you need to add more shadow. The artist added deeper tones around the nose, ears, chest, paws and eyes.

Scrape out the whiskers around the nose and eyes with the craft knife.

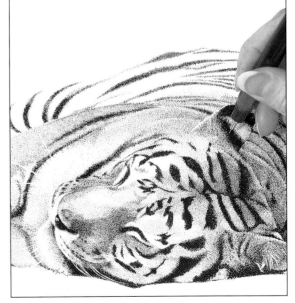

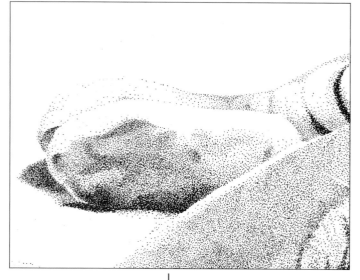

◀ **11** Add fine shading over the back end of the tiger, using the same approach as for the front. Stipple in tones on the back paws to suggest the muscles under the skin, with dark tones where the paws turn towards the ground. Add shadows to the ground around the paws to make them sit neatly on the ground.

Look at the top outline of the top back paw – in the photograph, this area is not clearly visible because it receives direct sunlight. However to hold the outline together for the purposes of this picture, the artist used fine, widely spaced dots.

Tip

Scratching out and burnishing

If you're unhappy with some of your marks, use a sharp craft knife to scrape your pen marks off the paper carefully. If you want to work over these areas, burnish them (rub them hard to flatten the surface of the paper) with your fingernail.

▶ **12** To emphasize the whiskers, stipple in some very fine dots along the length of a few of them, where they are invisible against the background.

Now tidy up and finish off. Put more shadows on the nose to define the highlights, then add some shadows on the ground to anchor the tiger – around the front paws, leg and the head. Keep the foreground shadows to a minimum so that the emphasis remains on the tiger.

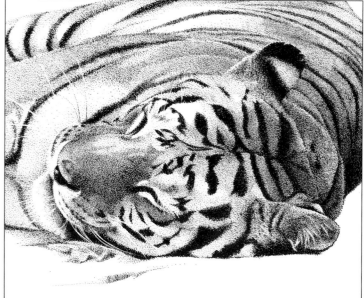

▼ **13** The finished drawing shows how striking such a simple technique can be. Form, tone and texture are all convincing because of the artist's patient attention to small detail. There's a good sense of the weight of the paws, the solidity of the sleeping tiger, and even of the way the side of its face is flattened against the ground, trapping the whiskers beneath.

Line and colour washes

Mixing two media can often bring out the best in both. Fine ink work and soft watercolour washes can be combined to produce drawings of great charm and delicacy.

As we have already seen (on page 27), transparent watercolour wash partners pen and ink extremely well. Both mediums have an intrinsic delicacy which gives the drawing a light touch and ensures that neither medium overwhelms the other. At the same time, the strength and vivacity of pen and ink contrast well with the translucency of watercolour.

In the drawing on pages 27–30, the artist used watercolours selectively to highlight – and enliven – a pen-and-ink still life drawing. Here, broad watercolour washes give mass and tone while pen-and-ink line provides fine detail and structure to a drawing of a Venetian canal.

The artist chose to use brown ink, which is softer than black and mixes well with watercolours – harmonizing particularly well with earth colours, such as burnt umber, yellow ochre and raw sienna. Her gentle washes aim to catch a sense of the structure and bulk of buildings, bridges and water.

Both the watercolour and the pen detailing are worked quickly – the artist wanted to catch the spirit of the place rather than render elaborate detail. Throughout, her concern was to keep the balance of tones right. Some of her colours stray from those in her photo, but this was done deliberately to enhance the effect.

▼ **This pen, ink and watercolour drawing, using waterproof brown ink for the linear details and transparent watercolour for mass and tones, has captured the spirit of this picturesque canal-side scene.**
'Campo Santa Maria Formosa' by Lynette Hemmant, ink and watercolour on paper 10 x 12in (25 x 30cm)

Room with a view

◄ **The set-up** The artist was delighted to stay in Venice in a house with this wonderful view. Sketching from a balcony or window gives you comfort, privacy and some welcome shade.

▼ **1** Lightly pencil in the position of the buildings, bridges and canal. Now liberally apply a series of thin watercolour washes with your No.8 brush, allowing them to run into each other softly to create delicious new colour mixes – the artist used terre verte, burnt umber and a touch of yellow ochre. These washes establish some of the tones and prevent you from getting too carried away with the pen details at this stage.

▲ **2** Once the washes are dry, define the buildings with your dip pen and ink, just putting in the basic outlines. (If the washes are still wet, the ink will run – though you can use this to your advantage.) Don't simply trace over your pencil marks or the result will look flat and mechanical. Keep your pen work lively, using the pencil lines only as rough guides.

► **3** Carry on building up tones, introducing washes of cobalt blue, viridian and Venetian red and adding more yellow ochre. Then elaborate the existing pen lines slightly.

 The artist used colour creatively to link different areas – the cobalt blue on the canal is echoed on the roof tops, for example. Most of the washes are applied wet on dry, but some wet into wet washes soften the effect and create new colour mixes as the wet washes blend.

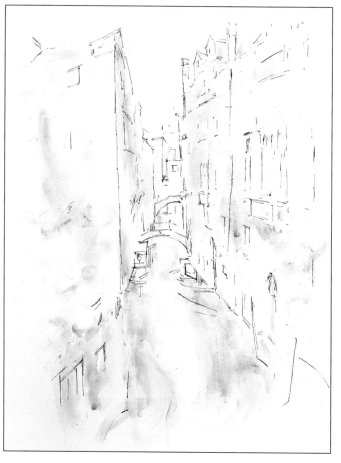

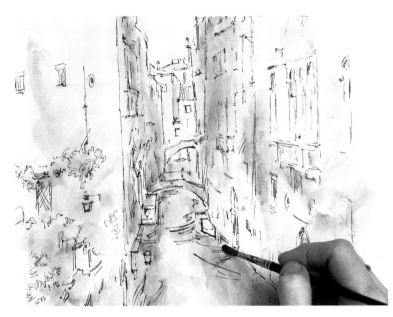

◀ **4** Taking care to keep things spontaneous, work on the details – roofs, windows, balconies and window boxes – with pen and ink. Use the pen freely, and vary your strokes so that the marks suggest the subject. The artist rendered the plants on the left with loose scribbles and the window panes with long, straight strokes; a little cross-hatching emphasizes darker tones.

Add more delicate washes of colour – thin cobalt blue for the sky and more yellow ochre, burnt umber, Venetian red and blue on the buildings.

▶ **5** Continue in the same manner, alternating washes of colour with pen and ink, and working on all areas of the picture to maintain the balance of ink and wash. Keep the washes fairly light so that they don't dominate, but don't be afraid to go over them with another wash of the same colour if you wish to add more depth, as the artist is doing here with the sky.

▼ **6** Add a few splashes of colour where you think your sketch needs it. The artist added flashes of Venetian red for the geraniums on the balcony, and balanced it with a little Venetian red on the gondola under the bridge. Some extra pen lines give the geraniums more substance and weight.

Tip

Wet wash
If you apply your washes liberally, as the artist did, you may get a few runs. Keep

some kitchen paper to hand so that you can soak up any trickles of paint before they stain the paper.

▼ **7** Work in a few more details – the artist refined the balconies and emphasized the lamps to accentuate the Italian feel. She also put in a couple of figures on the first bridge and another on the second in pen and ink. These rather endearing figures add scale. Note that the pen marks are light, not heavy-handed.

8 Strengthen some of your lines to suggest shadows and to convey the crumbling condition of the stonework. If any of the tones need more depth, use your No.5 brush to go over the washes again with the same colour. Don't go over the wash exactly – you get much more variety if the edges don't match precisely. Leave the washes to dry thoroughly.

Now touch up any details with the pen, being careful not to overdo things. If it looks good as it is, don't change it.

▼9 The final sketch captures the atmosphere of this romantic canal in Venice without actually copying it detail for detail. There's enough information to convey the style of the place and to suggest the different textures – the smooth, murky water, crumbling stonework and flourishing geraniums – but not so much that it looks overworked.

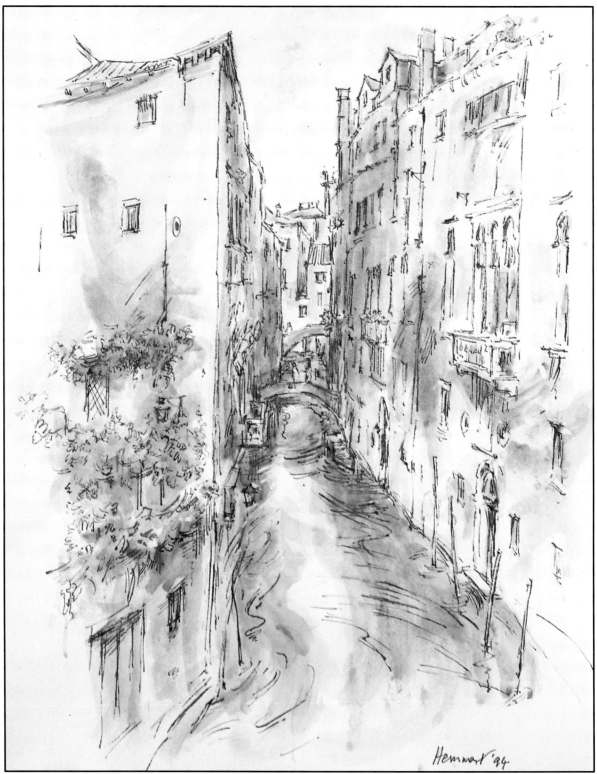

Line variations and colour washes

A small still-life study will enable you to explore the use of Indian ink lines with watercolour washes to create lively, textural effects.

The combination of watercolour washes and pen-and-ink line is good for rendering light-filled landscapes – where sweeping ink lines and washes give an impression of airy brilliance – but also, on a smaller scale, the technique is extremely effective for portraying very delicate natural objects.

In this still-life demonstration, for example, the fine pen line captures the brittle form of the sea shells, while the sensitive washes evoke their subtle hues and slightly reflective glaze. The two work very closely hand in hand all the way through this demonstration, the one enhancing the other at every stage.

When using pen and ink, try to vary the thickness and tone of the line. A varied line brings vitality while an undifferentiated one deadens your subject. You can achieve variation of line width by applying different pressures to the pen, or by using the side or back of the nib, and variation of tone by loading the pen with different amounts of ink. Working wet into wet and wet on dry will also add textural variety to your work.

The artist used a limited range of colours for his washes, reinforcing the impression that the objects were alike in substance. Moreover, to allow the shells to stand out, he touched in the background only very lightly.

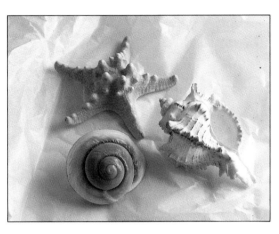

◀ The set-up The shells picked out for this still life are three different geometrical shapes – a spiral, a star and a rough cone. The artist arranged them carefully so that they interact – the point of the cone and the spiral shell seem to fit in the spaces between the arms of the starfish. The background is a sheet of waxed paper, slightly crumpled to create small undulations and light shadows.

▶ 1 First outline the forms lightly in pencil. Aim to locate the arrangement slightly off-centre on the paper – this makes for a more interesting composition. When you feel satisfied with the shells' positions and shapes, go over the outlines with Indian ink and your dip pen, varying the thickness of the lines for a lively look.

◀ 2 When the ink outlines have dried, you can use the No.4 brush to touch in washes of dilute Indian ink for areas of deep shadow on the background, burnt sienna for parts of the spiral shell and starfish, and alizarin and burnt sienna for the mouth of the spiky cone-shaped shell. Pay attention to the direction of the light (in this case it is from right to left) and, as you paint the shells, make the wash more dilute when you are covering well-lit areas.

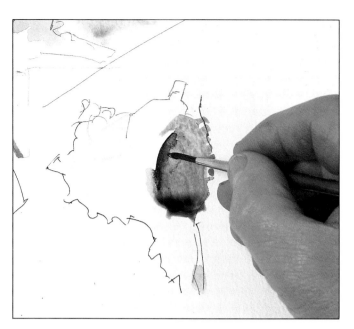

▶ **3** Again using the No.4 brush loaded with dilute Indian ink, fill in the mouth of the spiky shell. Let it run a little into the still-wet alizarin and burnt sienna on the lip, and make the black more intense where the shadow deepens inside.

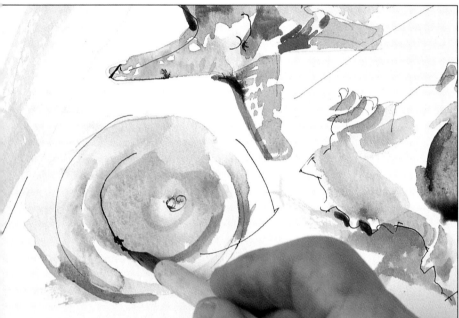

◀ **4** With a very dilute wash of cobalt blue, patch in areas of shadow on the background. Adding a very little Indian ink, use the wash to cover areas of shadow on the spiky shell and the shadow beneath it. Mottle darker areas of the starfish with burnt sienna. Emphasize the shadows under the legs of the starfish with pen line, gently 'bleeding' it off with a little water. Finally, with pen and ink, draw in the segment lines of the spiral shell.

▼ **5** When the paint is dry, use a more dilute wash of Indian ink and cobalt to fill in the space between the spiky shell and the starfish, and between the spiral shell and the left background shadow.

Now give more substance to the shells. Using the brush and cadmium yellow deep, add more mottling to the starfish. Add burnt sienna with a touch of alizarin to the shadow of the spiky shell, then go over the shadows of the spirals on the left shell with a more dilute burnt sienna wash.

YOU WILL NEED

- ☐ A 12 x 18in (30 x 46cm) sheet of good-quality smooth drawing paper
- ☐ A No.4 round watercolour brush
- ☐ An HB pencil
- ☐ A steel-nibbed dip pen
- ☐ Two jars of water
- ☐ Watercolour palette
- ☐ A bottle of Indian ink
- ☐ Five watercolours: alizarin crimson, cadmium yellow deep, Payne's gray, burnt sienna and cobalt blue

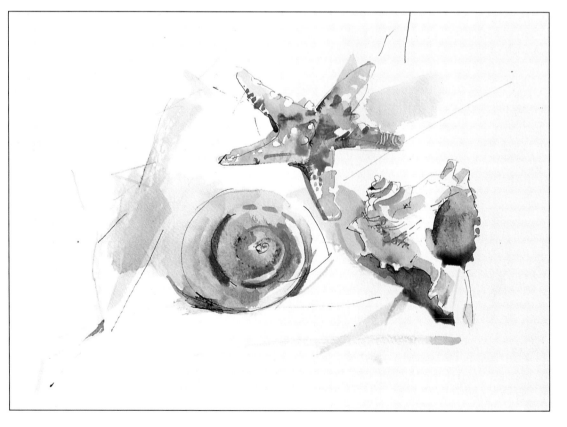

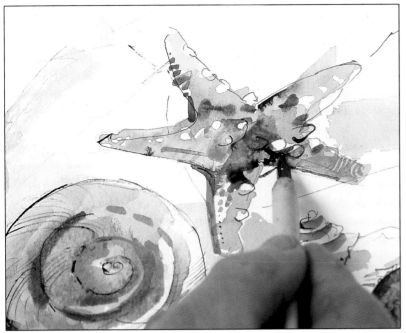

◄ **6** When the last wash has dried, begin to work on the details of the shells. Use the pen and a full load of ink to draw in the knobbly skin of the starfish (you can blotch this with a little water to vary the texture, if you wish).

With dark ink, emphasize the far outline of the spiral shell. Dilute the ink to draw in the hairline markings on each shell-segment. Do the same for the more broken markings on the spiky shell.

► **7** With the dip pen and ink, continue to work up the details on all three shells, aiming to bring them all on at the same rate. Deepen the shadows on the skin of the starfish, and add a tinge of burnt sienna to the middle of the spiky shell where the shadow meets the light.

Stress the left outline of the spiral shell with slightly diluted Indian ink, and add more contours to the shell with cobalt blue paint, using the very tip of the round brush.

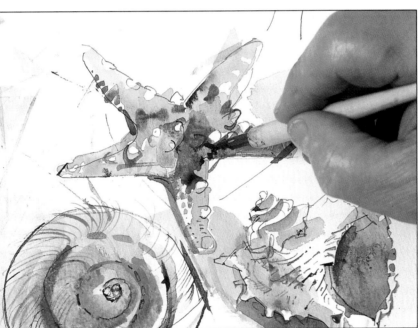

◄ **8** Concentrate now on adding more detail to the spiky shell. Vary the intensity of the surface markings using various strengths of ink. If necessary, go over parts of the the shell's left outline with the back of the pen nib.

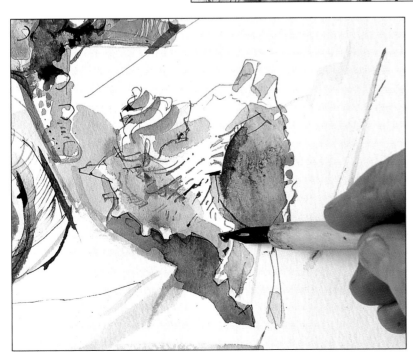

▶**9** The spiral shell has a bluish sheen in places. Brush in a wash of cobalt just below its tip and over some of the hairline markings made with Indian ink. Add streaks of cobalt blue and Payne's gray to the background to suggest the variety of shadows on the paper.

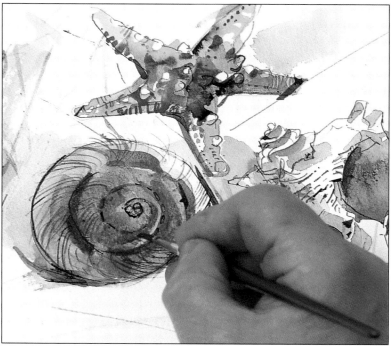

▼**10** To finish the drawing, use the brush to fleck the lip of the spiky shell with alizarin and burnt sienna, and add the faintest touches of the two colours, mixed, to the starfish. A broken brown-black line down the middle of the spiky shell helps to suggest the form.

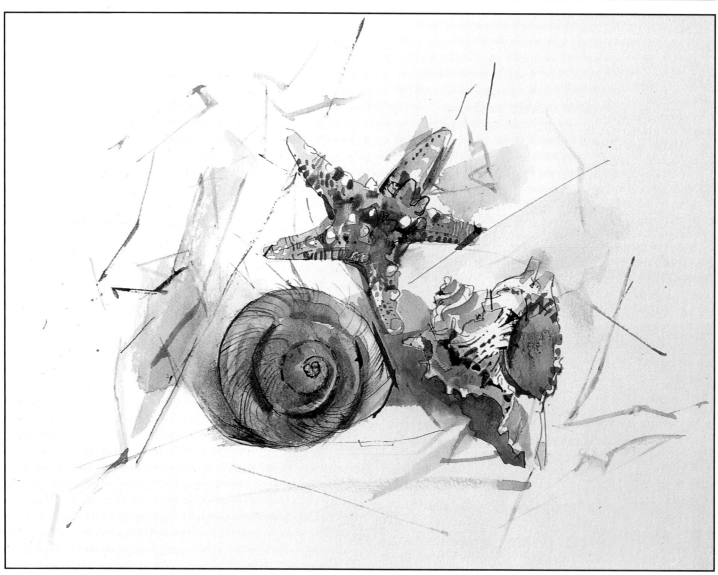

Index

Projects are indicated by the use of *italics*

Acknowledgements

1 Stan Smith, 3(l) Melvyn Petterson, (c) Emma Ronay, (r) John Raynes, 4 Ken Cox, 5 Stan Smith, 7 John Ward, 8(t) Anne Wright, (c) Sue Smith, 9(t) John Raynes, (b) Gordon Bennett, 10(tl) Stan Smith, (tr) John Tookey, (b) Dennis Gilbert, 11 Gillian Burrows, 12 Jennifer J. Tuffs, 13 John Raynes, 14 Stan Smith, 15-20 Ian Sidaway, 21 Stan Smith, 23-26 Emma Dodd, 27-30 John Raynes, 32-46 Stan Smith, 47-52 John Raynes, 53-56 Sally Michel, 57-62 Ian Sidaway, 63 Lynette Hemmant, 64 Anne Wright, 65 John Ward, 66-68 Stan Smith, 69-72 Mary Malone, 73 Albany Wiseman, 74-76 John Raynes, 77-80 Lynette Hemmant, 81-84 Sam Findley, 85 Visual Arts Library, 86-88 Stan Smith, 89-92 Ken Cox, 93-96 Hamlyn Books/Paul Forrester, 97-100 Emma Ronay, 101-102 Anne Wright, 103-106 Melvyn Retterson, 107 Audrey Hammond, 108-110 John Raynes, 111-114 Ian Sidaway, 115-118 Sue Smith, 119-122 Lynette Hemmant, 123-126 Stan Smith.

Thanks to the following photographers:
Julian Busselle, Michael Busselle, Mark Gatehouse, Patrick Llewelyn-Davies, Ian Howes, Robert Pederson, Graham Rael, Nigel Robertson, Steve Shott, George Taylor.